IMAGES
of America
LOS OLIVOS

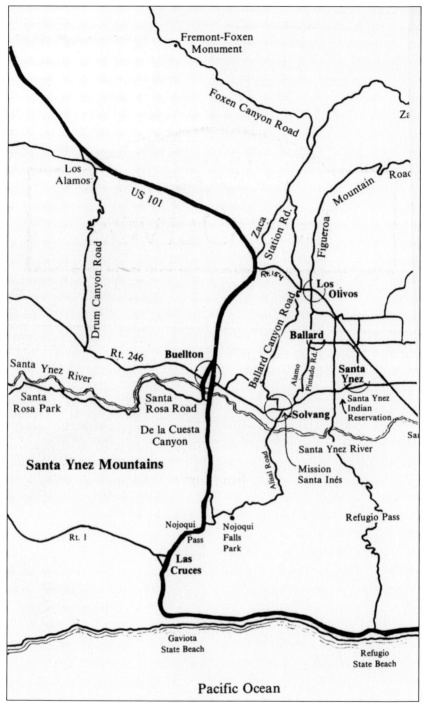

This Los Olivos area map shows its setting in the picturesque Santa Ynez Valley.

ON THE COVER: Mattei's Tavern, the most emblematic building in the Santa Barbara County settlement of Los Olivos, is depicted with a stagecoach and six horses, or "a stage and six," ready to roll at the front door. (Author's collection.)

IMAGES
of America

LOS OLIVOS

Jim Norris

ARCADIA
PUBLISHING

Published by Arcadia Publishing
Charleston SC, Chicago IL, Portsmouth NH, San Francisco CA

Printed in the United States of America

Library of Congress Catalog Card Number: 2007936582

For all general information contact Arcadia Publishing at:
Telephone 843-853-2070
Fax 843-853-0044
E-mail sales@arcadiapublishing.com
For customer service and orders:
Toll-Free 1-888-313-2665

Visit us on the Internet at www.arcadiapublishing.com

CONTENTS

ACKNOWLEDGMENTS

Over the years, I have been a reader at libraries, museums, trusts, and historical and genealogical societies from Marysville to San Diego in California and in Hawaii. Several hundred people have shared their collections, identified photographs, and sat for me, offering historical nuggets from their special memories while I taped their stories.

I owe a special thanks to the following: Laura Abeloe, Joanne (Bard) Newton, Gordon Bennett, Georgia (Bermudez) Hames, Jim Blakley, Harlan Burchardi, Bunny (Campbell) Barnes, Leona (Alfonso) Kamen, Rosario Curletti, Norman Davidson, Elva (Davis) Beatty, Mary Louise Days, Carolyn (Donahue) Henning, Margaret Downs, Leonard Fisher, Dennis Fitzgerald, Joy (Gillum) Chamberlain, Charlie Gott, Pete Grossi, Laura (Hanlon) Pringle, Doug and Sue Herthel, Myra (Huyck) Manfrina, Chuck Irwin, Kris and Olga Klibo, John Johnson, Andy Joughin, Peggy (Lang) Vernor, Laura (Lewis) Alegria, Jeannette Lyons, Fraser MacGillivray, Katherine (Montanaro) Fitzgerald, Coogan Munoz, Bud New, Richard Nosser-Smith, Eulalia (Armenta) Ochoa, Tom Peterson, Betty and Bill Phelps, Mike Redmon, Gertie (Rice) Campbell, Glenn Roemer, Dale (Rhodehamel) Rossi, Howard and Ruth Sahm, Grace (Shanklin) Mathiesen, Carl Sides, Clif Smith, Margaret (Smith) Chester, Bobbie (Snodgrass) Canet, Hester Stonebarger, Bill Toll, Margaret (Torrance) Doty, Barbara (Tunnell) Phillips, Ailie (van Loben Sels) Chamberlin, Bob and Betty Whitmore, and Cash and Meridith Wolford. I am sure I owe my gratitude to many others, and if I have neglected to list any, I apologize for the oversight.

Others who have been particularly knowledgeable and helpful are Myrtle (Edsell) Buell and Charlie Ochoa of the Santa Ynez Valley and Walter Hartley and Berdie (Summers) Hanson, who were both born in Los Olivos.

Photograph courtesies and/or credits are indicated in parentheses following the captions. All other photographs are from the author's collection.

INTRODUCTION

Los Olivos has been a well-used California crossroads, situated as it is in the Santa Ynez River Valley of Santa Barbara County, functioning as a gateway to the San Rafael Mountains and the Sierra Madre in what became Los Padres National Forest. The many crossroads that have wended through town include Native American trails, the old El Camino Real, coastal stage routes, and the railway—all traveled by sea captains, gold miners, Fremont's army "march," immigrants, squatters, land speculators, sheepherders, dairymen, farmers, adventurers, cowboys, oil men, pioneers, highwaymen, sportsmen, explorers, artists, wine aficionados, hikers, bikers, and Sunday drivers. Historically they have all passed through this small community.

With even a cursory glance, visitors perceive the immediate charm of Los Olivos. The nearby mountain vistas, national forest, wide streets, historic scenic buildings, friendly faces, excellent restaurants, horse ranches, and wineries all tell a visitor he is in touch with something unique and important.

The human history dates back to bygone eras of the Native Americans, known in recorded history as the Inezeno Chumash. For approximately 9,000 years, Native Americans have occupied villages in the Santa Ynez Valley. Generally situated near a year-round water source, several of these villages were located near what is today's Los Olivos: Xonxonata on Zaca Creek adjacent to the junction of Highways 101 and 154, Soktonokmu to the north in Birabent Canyon, and an unnamed and undocumented site south of town near an intermittently flowing spring east of Grand Avenue. The prevalent use of the word "Chumash" to represent this area's Coastal California Indians is contemporary and originally identified the Northern Channel Island groups. According to anthropologist John Johnson in 1987, "The Santa Ynez Valley Indians called this area 'Samala.' " Friar Zephyrin Engelhardt of the Order of Friars Minor identified 47 villages associated with Santa Ines Mission records.

Because of disease, the population of local Native Americans was drastically reduced, and few remained when the Santa Ynez Indian Reservation was established by the federal government. Studies conducted by anthropologist John P. Harrington, which were followed by those of John Johnson, Travis Hudson, Thomas Blackburn, and Jan Timbrook, have noted the complex religion, language, family, native plant use, material culture, "tomal" or boat construction, matrilocal organization, trade, art, and basketry of the Chumash. The success of the Chumash Casino today, the valley's largest employer, has rapidly changed the economic and educational status of the 153 members of the local reservation. A possible 2,000 Santa Ynez Valley reservation members are all descendants of Margarita (Corrales-Cota) Bernal and her daughter, Rosa. An ongoing DNA study will hopefully answer questions about the migration paths of not only the Chumash, but possibly all Native Americans.

After the Santa Barbara (1786) and Purisima (1787) Missions were established, the mission fathers realized they could not adequately serve the large Native American population along the Santa Ynez River. A suitable site, Alajulapu, on the bluff north of the river was selected, and in 1804, Mission Santa Ines, named for St. Agnes, was founded by Friar Presidente Estevan

Tapis. The first church was a crude *enramada*, but eventually the local Native Americans built a succession of adobe churches and buildings. In theory, the land was to be held for 10 years, after which time the Christianized and educated Native Americans would be given the land and govern themselves. This never happened.

Prior to the Treaty of Guadalupe Hidalgo in 1848, ceding California to the United States, retired Mexican soldiers were granted coastal California ranchos of up to 11 leagues or about 47,000 acres. The large sizes of these ranchos seem excessive today, but there were few ranchers and no fences at that time. Early American and English sailors married into the rancho owners' families, eventually creating a drastic cultural shift. Ownership gradually moved to the Americans, who continued the otter-fur, cattle-hide, and tallow trade following the maritime trade route of Boston, Hawaii, California, Pacific Northwest, China, and back to Boston.

On December 21, 1846, Lt. Col. John C. Fremont, accompanied by his "rag-tag army," marched from William Dana's rancho in Nipomo, down Foxen Canyon to what is today's Ballard. Bivouacking here while he searched for horses, Fremont then continued over the San Marcos Pass in a blinding rainstorm, sliding and tumbling down the Santa Ynez Mountains to today's Goleta. Resting here, he gathered up his weather-beaten troops and, without firing a shot, "captured" Santa Barbara the following day. He then continued on to Los Angeles, where he helped write the Treaty of Cahuenga on January 13, 1847, temporarily ending the Mexican-American War.

While William Foxen is erroneously given credit for helping Fremont avoid an ambush at Gaviota, it should be remembered that Santa Barbara's available solders were fighting in Los Angeles and that Fremont was familiar with the Santa Ynez Mountains, having previously crossed them. Fremont is noted as the "Pathfinder," a sobriquet that should probably go to Kit Carson.

During the second half of the 19th century, ranchers and settlers began populating the wilderness. Early Los Olivos families, many lasting into the 20th century and up to today, include Anderson, Ashabraner, Ballard, Barnes, Berg, Birabent, Bloodgood, Boyd, Brown, Calkins, Campbell, Carricaburu, Casserini, Columbo, Chamberlin, Cook, Cooper, Cox, Crawford, Davis, DeVaul, Downs, Eddy, Edgar, Fields, Fitzgerald, Fleenor, Fordyce, Fox, Fraters, Gott, De la Guerra, Hartley, Henning, Heyman, Hinton, Hutchison, Keenan, Lang, Lansing, Lawrence, Lewis, Libeu, Luton, MacGillivray, Martin, Mattei, McGinnis, McGuire, Miller, Montanaro, Navarro, Ortega, Osborne, Parr, Peck, Rice, Rudolph, Sahm, Schneider, Short, Sides, Smith, Stonebarger, Tolladay, Tunnell, VanEtten, Waugh, Weir, and Whitcher.

One

NATIVE AMERICANS AND THE MISSION

The early success of Mission Santa Ines was documented from 1804 to 1850 with the following numbers: Native American totals: 1,631 baptisms, 497 marriages, and 1,632 deaths; white totals: 47 baptisms, 8 marriages, and 15 deaths. Agricultural crop harvests were as follows: maximum bushels harvested between 1804 and 1834 were wheat (1821) 3,600; barley (1821) 800; corn (1812) 3,000; beans (1821) 620; and peas (1813) 520, for a mission bushel total of an impressive 11,657.

In 1824, the Native Americans at Santa Ines, Purisima, and Santa Barbara Missions revolted and held the missions for a period of time before soldiers arrived from Santa Barbara and Monterey to quell the insurrection. Numerous other revolts took place between the Alta California Indians, the missions, and the soldiers.

Native American housing was constructed south of Mission Santa Ines near the *lavenderia*, but, unfortunately, it has melted away. Across the valley, a gristmill was in use, then Joseph Chapman built a fulling mill. Santa Ynez Valley Union High School students recently documented the gravity water system of Mission Santa Ines.

In December 1845, Gov. Pio Pico illegally granted a nine-year lease of the mission for $580 a year to Jose M. Covarrubias and Joaquin Carrillo and, in June 1846, sold it to the same gentlemen for $7,000.

The mission has been remodeled but never architecturally restored. The original church decorations have been repainted, and the bell tower was rebuilt. The vestment collection is one of the most complete in Alta California, and the museum provides daily tours. Mission Santa Ines is on the National Register of Historic Places. On May 23, 1862, Bishop J. S. Alemany was patented 17.35 acres, an area now surrounding Mission Santa Ines.

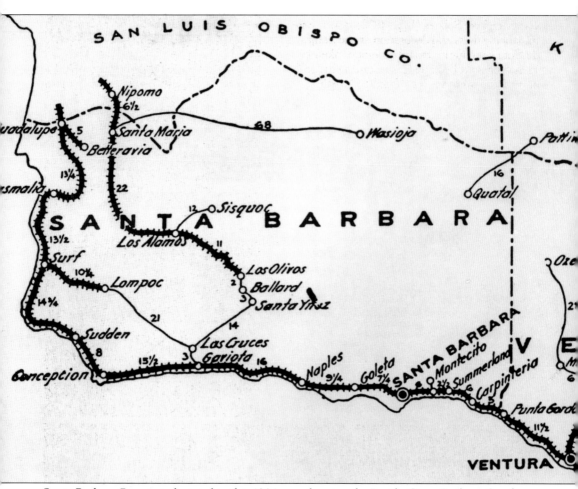

Santa Barbara County is depicted in this 1904 map showing the Pacific Coast Railway, Southern Pacific, and connector stage lines. (*County Atlas of California*, Monterey Library.)

Capt. Raphael Solares (1822–1890) is seen here in dancing dress and decoration at the Zanja de Cota community in a photograph taken by French captain Leon de Cessac during his 1878 around-the-world voyage. (Lucille Christie.)

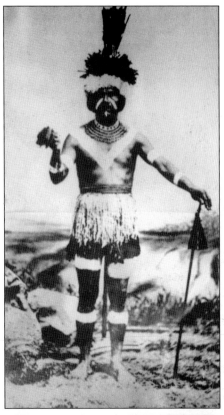

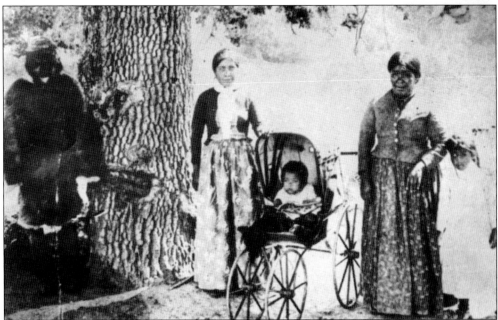

Pictured from left to right in this *c.* 1887 reservation photograph are Capt. Rafael Solares in a bearskin cloak, Maria Solares (1842–1922), Clara's child Jasper in the buggy, Clara Candelaria Solares, and Isabel. (Charlie Ochoa.)

This is one of the early adobes at the entrance to the Santa Ynez Indian Reservation. All the adobes have been torn down. (Charlie Ochoa.)

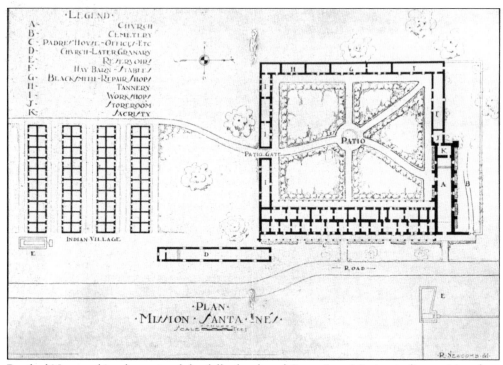

Rexford Newcomb's schematic of the fully developed Santa Ines Mission indicates 24 arches. The adobe patio walls, Native American village, and the granary have melted back to the earth. (Newcomb Archives.)

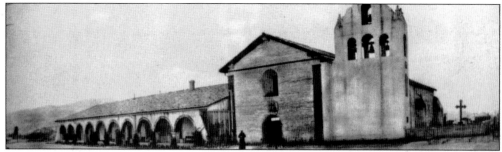

Two earthquakes, the 1824 revolt, and several drenching rains damaged the mission. The bell tower here was rebuilt but not in its original configuration. The photograph shows Santa Ines Mission with 10 arches remaining, the ruins of the 19th arch on the far left, the bell tower with five openings, and the cemetery with a large cross on the right. Amat's Store was at the bottom right.

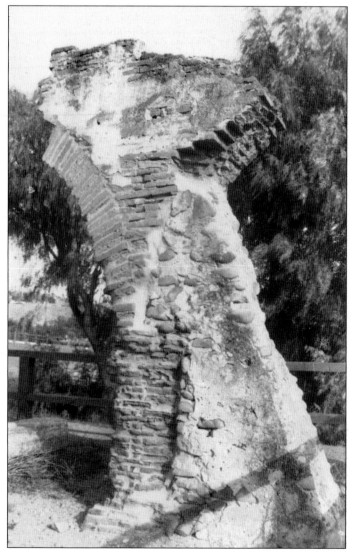

Ruins of the 19th arch show the original fired red pavers, repair, and white stucco exterior coat.

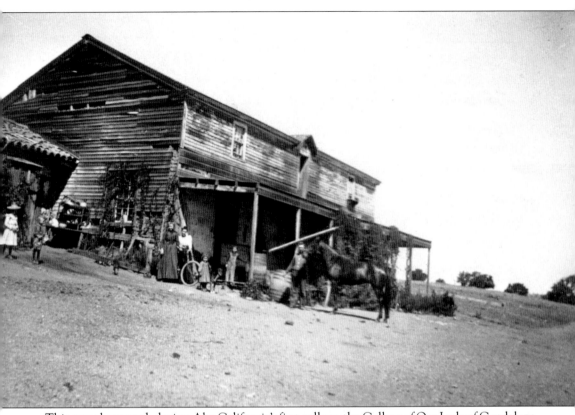

This rare photograph depicts Alta California's first college, the College of Our Lady of Guadalupe, on Refugio Road several miles east of Santa Ines Mission. In 1844, Bishop Garcia Diego began a diocese seminary at the mission. Formally established in 1845, it was called the College of the Most Holy Mary of Guadalupe of Santa Ines of the Californias. After it was moved to Refugio Road, the name was shortened. Attendance at the college varied from 12 in 1854 to 25 in 1882, its final year of operation. Yearly tuition in 1874 was $125. Many pupils were sons of local rancho owners. Among attendees were Samuel Ambrose; Agapito Cabrera; Elisha Colt; Cressino Eduardo, Nicholas, and Onesimo Covarrubias; Carlos, David A., Edward G., Eliseo, Frederick A., John F., Jose Ramon, Samuel A., and William Charles Dana; Eduardo, Gerardo, and Leonardo de la Cuesta; Prospero de la Fontaine; Juan de la Guerra; Alfonso, Manuel, and William Den; J. B. Dieu; Maria Antonio de la Cruz Foxen; John and Thomas Hill; J. J. Jimeno; Caesar Lataillade; Emmanuel Lujan; Augustine, Frank, and Harry Maguire; ? Mallagh; Thomas More; Juan Moreno; Bob and Pete Mounier; Charles Olvera; Dario, Leopoldo, and Orester Orena; Joseph Pleasant; Carnelo Rios; F. Sanchez; Alfred Stokes; and Antonio Maria Villa. One of the cooks at the college was Jose Domingo Pajuri from Hawaii.

Two

ROMANCE OF THE RANCHOS AND RANCHING

During the Gold Rush, Southern California cattle quickly became an important commodity. But the cattle business was severely curtailed by the drought of 1863–1864, when many ranchos changed hands because of mortgage problems.

After statehood in 1848, all rancho grantees had to legally prove their ownership to the California Land Claim Commission. The claimant to the commission was not necessarily the rancho grantee, for the rancho might have been encumbered or sold. Title was not cleared until the claimant paid for a U.S. survey, and patents to the surveyed rancho areas were issued by the president of the United States. This process could take up to 30 years! During this waiting period, legal fees mounted, and the ownership (whole or part) of many ranchos changed hands.

In 1888 and 1889, a Squatter's League was formed and settled on the Brinkerhoff, north of Santa Ynez. By February 1889, most squatters had left the valley after losing a court battle.

A good example of an early Santa Barbara area ranch was the Peter Montanaro complex south of the town of Los Olivos. Peter had a cow and pig slaughterhouse, originally with a chalk-rock-creek chiller and then an ammonia cold box, holding pens, barns, and a small store. He sold meat from a wagon and a second store in Santa Ynez. His 1894–1895 account book lists 159 customers.

As transportation expenses escalated through the last half of the 20th century, dairying became uneconomical. With the closure of the valley's last dairy in 2006, a long farming tradition ended. Former Los Olivos dairies included Campbell, Columbo, Filippini, Fratis, Giacomazzi, Mattei, Montanaro, Oak Crest/Cobb, Sahm, Saulsbury, and Smith.

Horse ranching continues in today's valley. Thoroughbreds to miniatures are available for pleasure and sale, and many support organizations continue the fabled rancho hospitality traditions. Recently a carriage competition, team penning, and the Santa Maria Rodeo have added variety to the historic events. The Los Alamos Society limits membership to 49, and all members must own local property. Local members of the early Los Alamos Society were A. M. Boyd, Sam Calef, John MacGillivray, John J. Waugh, and Charles, Clarence, and Felix Mattei.

The Rancheros Visitadores ("RVs"), now 800 members strong, begin their annual trek with a blessing at Mission Santa Ines. Both the Los Alamos Society and the Rancheros Visitadores originally met annually at Mattei's Tavern in Los Olivos.

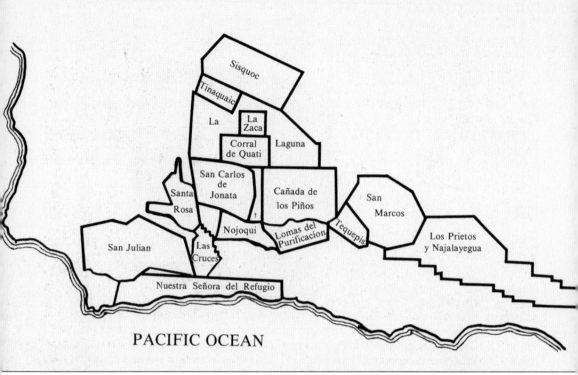

The map depicts the following ranchos: Sisquoc, Tinaquaic, La, La Zaca, Corral de Quati, Laguna, San Carlos de Jonata, Cañada de los Piños, San Marcos, Santa Rosa, Nojoqui, Lomas del Purificacion, Tequepis, Los Prietos y Najalayegua, San Julian, Las Cruces, Nuestra Señora del Refugio.

PACIFIC OCEAN

The Los Olivos area is depicted showing the associated patented Mexican ranchos and the dates the ranchos were awarded: La Laguna, July 9, 1840; Nojoqui, April 27, 1843; Alamo Pintado, August 16, 1843; Cañada de los Piños (College), March 16, 1844; Lomas de la Purifacacion, December 27, 1844; Tequepis, May 24, 1845; San Carlos de Jonata, September 24, 1845; Corral de Quati, November 14, 1845; and San Marcos, June 8, 1846. Not shown is the Alamo Pintado Rancho belonging to the Native American alcalde Marcelino Cunait. This rancho, which was not approved, then became homestead land and, eventually, the towns of Los Olivos and Ballard.

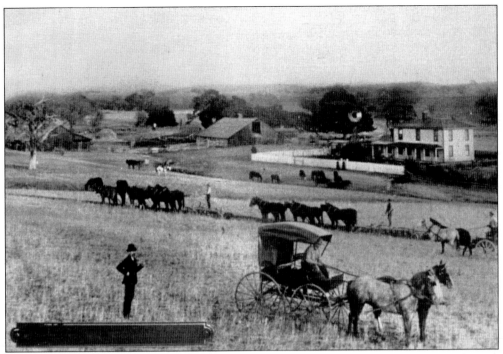

The John Thomas Torrence Ranch is depicted here in 1892. The large home and barns still stand, and the Santa Ynez Valley Pony Club trains and holds competitions here today. John Thomas married Mary Agnes Hails in Santa Barbara in 1893. Their children were Abbie, Minnie, Richie, Leslie, Sam, and Margaret. (Norma Shepard.)

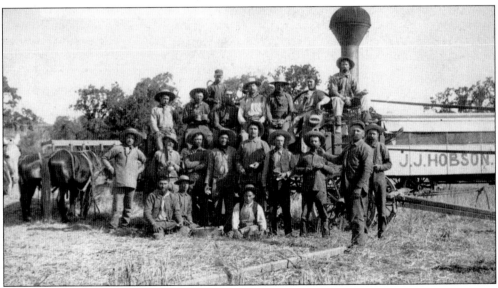

Ballard's John Jay "J. J." Hobson's threshing crew relaxes on their belted steam engine in August 1892. Hobson is in front. Straw was used for fuel. Ten-year-old Sam Lyons, who later became the Santa Ynez Valley justice of the peace, is in the white shirt in front. (Norman Davidson.)

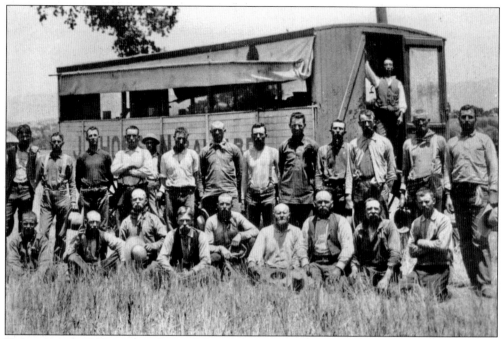

Hobson's crew of 20 poses in front of the Chinese cook and his chow wagon. Several 1900-era buildings are still standing on the site of Hobson's ranch on Alamo Pintado.

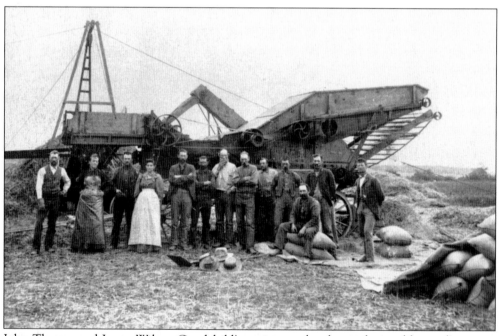

John Thomas and James Wilson Goodchild's stationary thresher is depicted here adjacent to Foxen Canyon Road near Sisquoc. John and James were born in East Tilbury, England. Their ranch was in the flat just west of the San Ramon Chapel. Both married daughters of Ramon and Magdelina Ontiveros.

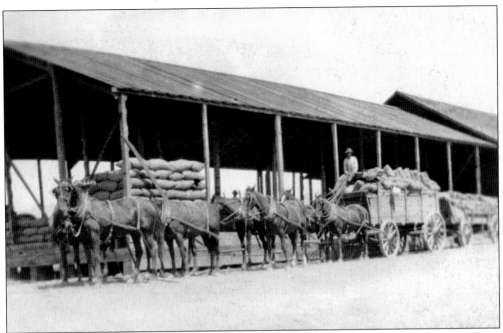

Lige Campbell, here at the Los Olivos train warehouse, drives a tandem-wagonload with an eight-horse hitch hauling grain from Buellflat. Each burlap sack weighed around 100 pounds. Lige ran a livery stable in Los Olivos and, until about 1910, delivered the mail from Los Olivos to Gaviota.

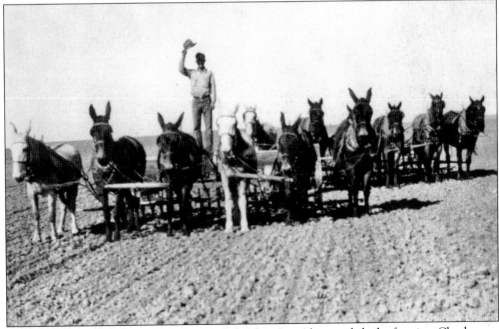

Charley Berry of Los Olivos drives a 12-mule hitch in Los Alamos while dry farming. Charley was born in Beulah, Colorado, in 1897. He came to Los Alamos, California, in 1915, then drove a team on a section-and-a-half of beans. He played banjo with the Los Olivos band, accompanied by band members Mary Harwood, Eddie and Bill Kelly, John McGinnis, and Charlie and Holly Burd.

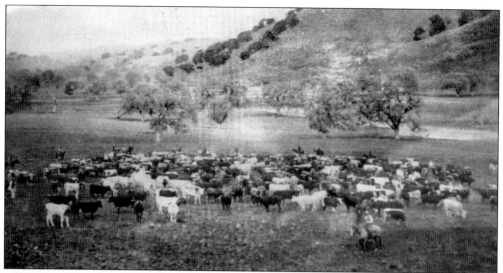

John MacGillivray leased "the Rancheria," using it for his roundups, which included shots, castration, and branding. After the sale, the cattle were driven to Wigmore Station, east of Los Alamos, and then boarded on the Pacific Coast Railway or driven to the Southern Pacific Yards at Gaviota for transport to the slaughterhouse. The Rancheria is in the area of the recently discovered Chumash site, Xonxonata, at the junction of Highways 154 and 101. (Bill Phelps.)

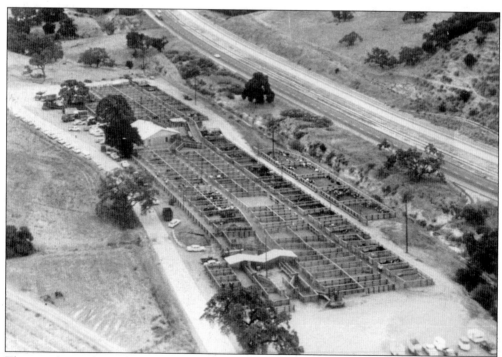

This aerial view shows the Buellton stockyard, which is now closed. Local cattle ranchers brought their stock to sell at this convenient location on Highway 101, north of Buellton.

The John Charles and Carlo Lawrence Marre Ranch is seen here in 1947, off Star Lane Ranch Road in Happy Canyon, Santa Ynez. Their sister Angelina Marre married a cousin, Luigi Marre, in 1881. Luigi owned the Marre Hotel in Port Harford, today's Avila Beach. A second sister, Virginia, married Umberto Minetti, who in 1915 owned the Pioneer Hotel and a deli in Santa Ynez. John Charles Marre's children were the legendary valley "strongmen" Pompeo and Dismo and their sister, Carolina. (Walter Cornelius Douglas.)

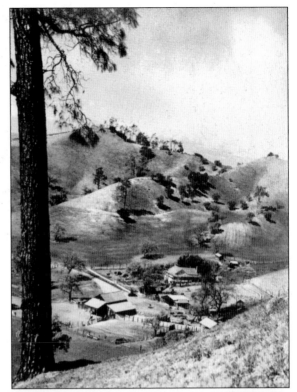

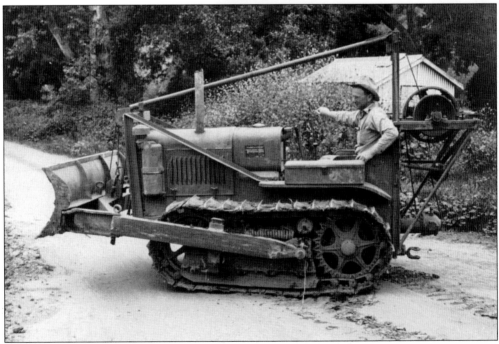

Stanley Hollister was photographed here on April 22, 1940, driving a belt-driven hoist, which was converted from an old hand winch outfit by blacksmith and photographer Jim Smith in his Goleta shop. (Jim Smith.)

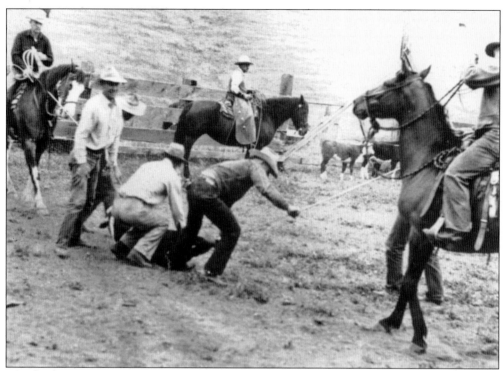

Branding at a roundup is depicted in Los Alamos. With generous help provided by neighboring ranchers, there may be more cowboys present than calves. A barbecue traditionally followed the roundup. Brands are registered with the State of California, and brands for each ranch are distinctive.

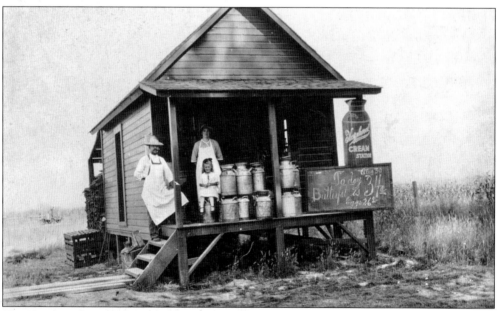

The Hazelwood Cream Station at the Solvang Creamery was photographed on August 30, 1914. Eggs were 26¢ a dozen and butterfat Grade B cost 34¢.

The Sahm Dairy complex, which included a barn, milk house, and silo, was adjacent to the family home on Hollister Street in Los Olivos. Pictured from left to right in 1945 are Isaac Sahm and his son, Howard. Three artesian wells were located in the creek behind the dairy, and they supplied water for the house and for a nearby Chinese laundry. Here 130 Guernsey cows were milked twice a day by hand. After 1930, they were milked electrically. The Sahm Dairy delivered milk throughout the Santa Ynez Valley. The extant, pre-fab, creek-sand concrete silo still stands in Los Olivos. Green-chop silage, air-blown to the top, gradually fermented and was removed at the bottom. The "likka," if fed to pigs or sampled by young boys, made them slightly tipsy.

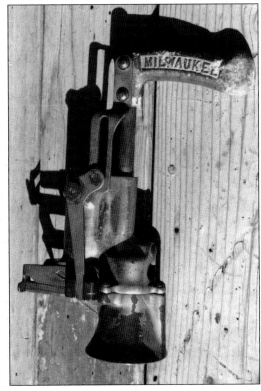

The Milwaukee milk capper was a mainstay device at the Sahm Dairy. The capper was used to cap 180 bottles of Grade A whole milk per day. Inspectors from Santa Barbara City, Santa Barbara County, and the State of California could come by at any time. The Sahms sold out in 1964.

Alden March Boyd is seen pressing olives in the 1890s at Ralph F. Selby's Rancho de la Mesita. Oil from this press was entered in international contests, but competition from foreign countries and California's Central Valley left little margin for profit, and Boyd pulled out some 5,000 olive trees.

This 1898 olive oil label was designed by Victorio Lopez. At this time, Alden M. Boyd was managing Selby's Mesita ranch. The Mesita Ranch is now commonly referred to as the Duff property.

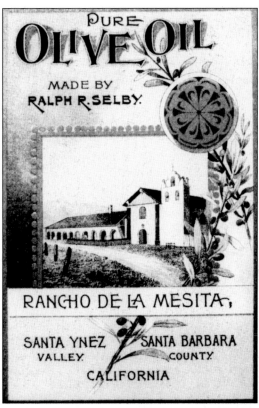

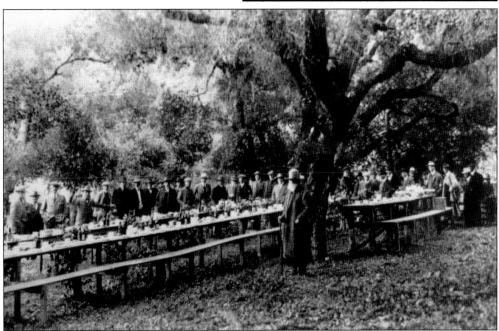

After the Los Alamos Society held their annual meetings at Mattei's Tavern, a member would host a barbecue at his ranch. Here 40 members are ready to sit down. Member John Waugh, with the white beard in front of the oak tree, was a former stage driver.

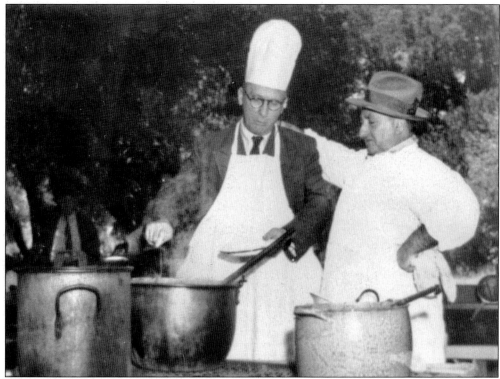

Chef Reno offers Los Alamos Society member Dwight Murphy a sample of his frijoles around 1946.

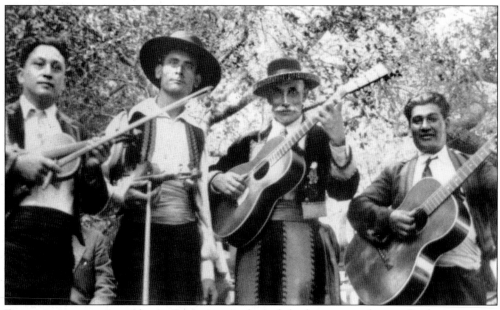

Entertainment at a Los Alamos Society annual ranch barbecue was always a lively event, as it was here in 1931.

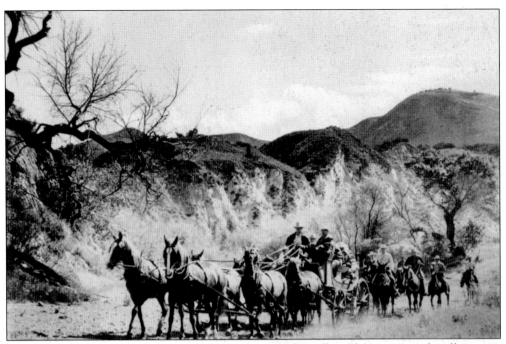

Rancheros Visitadores conducts annual rides through the valley. Their stagecoach collection is used to re-create the flavor of early California's rancho spirit and hospitality.

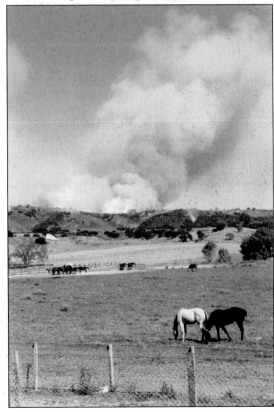

A constant threat to ranchers and forested California areas was, and is, fire. The 2007 Zaca fire covered more than 240,000 acres and was one of the state's largest. As many as 1,000 firefighting units and over 3,000 firefighters were on hand with helicopter and air-tanker support. The estimated cost to fight the Zaca fire was $117 million.

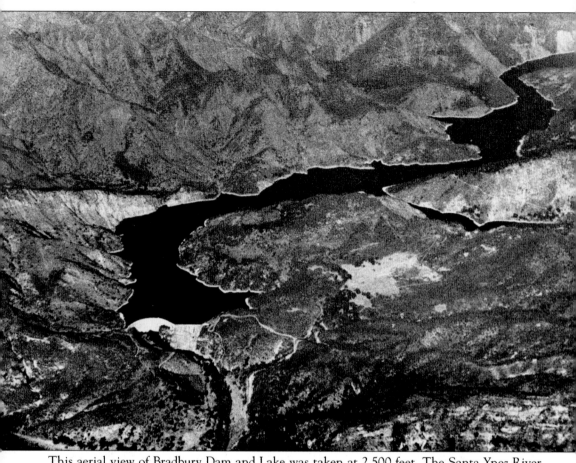

This aerial view of Bradbury Dam and Lake was taken at 2,500 feet. The Santa Ynez River continues to provide water for domestic and agricultural use. (Jim Smith.)

Three

THE COASTAL STAGE

In 1861, with the Civil War approaching, the U.S. Army decided better communication was needed between San Francisco, Los Angeles, and San Diego. Stage roads were constructed through each coastal county, and the first stage arrived in Santa Barbara in 1861. Through the years, the local stage was successively named the Overland, the Coastline, the Flint and Bixby, and the Los Angeles and San Juan. The stage continued until 1901, when mail was delivered on the Southern Pacific Railroad at Gaviota.

Following Foxen Canyon south from Nipomo, the stage line stopped at William Ballard's adobe, then continued past Mission Santa Ines, traversed Gaviota Pass, and continued south across many creeks along the oceanfront to Santa Barbara. The economic incentive and eventual survival of stage lines was dependent on the support provided by U.S. mail contracts. The Santa Barbara Turnpike was opened in 1870, and the stage route changed, crossing over San Marcos Pass. After Felix Mattei opened his hotel in Los Olivos, the local stage stop relocated from Ballard's to Mattei's.

Several local drivers/agents (partial dates of service are listed if known) were: William N. Ballard (1860–1870), Frank Barnes, A. J. Bouseke (before 1898), J. A. Brown (1888), Miguel F. Burke (1869–1874), Carl Campbell (1910–1914), Earl Campbell (1910), Harold Campbell (1914), John Campbell, Lige Campbell (1910–1914), M. T. Cheney (1888), Sam Childs (1888), George W. Coats, George Coe, Thomas Coe (1892), Frank Cook (1898), Harry Cook (1898), George "Whispering" Cooper, Miguel Cordero, Thomas B. Curley (1871), David H. Eastabrook (1896–1899), Oliver J. Farnum (1896), George Ferguson (1873), Oscar Hert (1888), Josie Hobson (1888), Nels Jensen, Charles Larzelere (1866–1869), George W. Lewis (1870), Fernando Librado (1890s), Felix Mattei (1886–1910), Jim Meyers, Walter Murray, R. D. Parrish (1890–1896), "Uncle" Charlie Patterson (1886–1897), F. M. Rundell (1875), Charles Schneider (1888–1935), F. M. Smith (1888), James W. Snodgrass (1909–1910), ? Stanton (1895), Charles Step (1901), "Budd" Swinney (1868–1869), John F. Van Etten (1890), John Waugh (1872–1900), Burt "Bee" Wheelis (1870), W. J. Wheelis (1870–1888), G. H. Wines (1855–1894), and Norman Wines (1886–1902).

Mattei and the Campbells in Los Olivos continued the stage run to Gaviota after 1901. After 1915, cars rather than horses were used for mail transport, but they were still referred to as "stages," with the Pickwick Stages adding to the confusion.

Many authentic-looking stage photographs are actually modern-day re-creations.

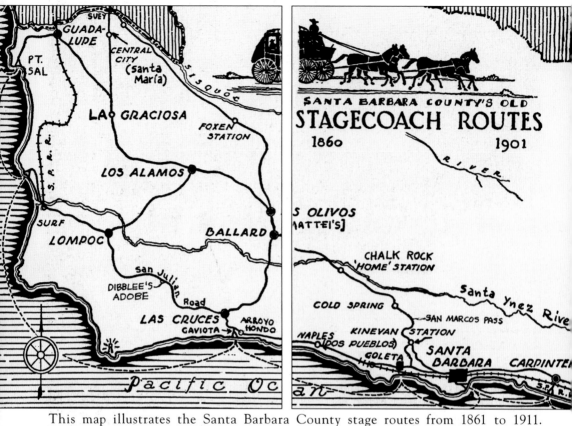

This map illustrates the Santa Barbara County stage routes from 1861 to 1911. (Walker Tompkins.)

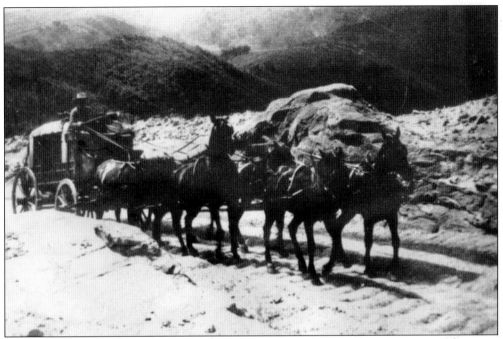

The Slippery Rock section of the stage route was located south of Kinevan's Stage Stop on San Marcos Pass. The mud wagon's iron tires wore ruts sometimes 14 inches deep, causing the drivers to move to the right or risk grinding through the wheel spokes. (Walker Tompkins.)

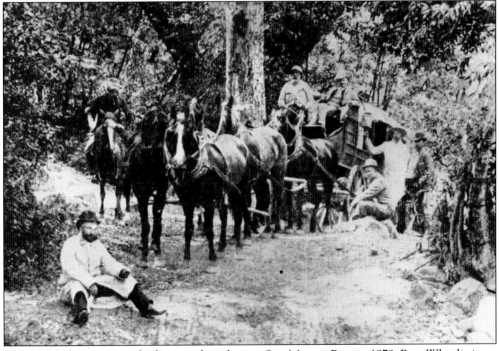

Jehu Ned Whitney gives the horses a breather on San Marcos Pass in 1879. Bert Wheelis is on the seat, either Tom Coe or Roland Thomas is in the white duster, and seated on the rock is a whiskey drummer. (Lorraine Mattei Johnson.)

Coast Scenic Stage Route from Santa Barbara to Lompoc

Call at Stage Office,
1231 State St.
Near Arlington Hotel

Ring Up
Telephone No. 31
Main

CONNECTING THE COAST ROUTE OF THE SOUTHERN PACIFIC COMPANY LINE FROM

LOS ANGELES TO SAN FRANCISCO

VIA SANTA BARBARA, LOMPOC, EL PASO DE ROBLES HOT SPRINGS, MONTEREY, SANTA CRUZ AND SAN JOSE.

Through Tickets Sold at Los Angeles and Santa Barbara to All Points.

STAGES LEAVE SANTA BARBARA DAILY AT 7 O'CLOCK A. M.

Tourists or other parties going North via the Coast Route of the San Marcos Pass, will find our equipments Number 1. Our rates, either by stage or private carriages, the most reasonable of any in Santa Barbara, with regular relays of horses along the route; all Baggage going by stage. For full particulars see folders at office of Southern Pacific Company, in Los Angeles, or at the Stage office, Santa Barbara, Cal.

All Daylight Traveling by this Route (over) **N. WINES, Manager**

A local 1887 stage ticket was sold either at 1231 State Street in Santa Barbara or at Mattei's Tavern. Norman Wines, the Santa Barbara manager, had the 1901–1902 Los Olivos–to–Las Cruces stage mail contract. (Clif Smith.)

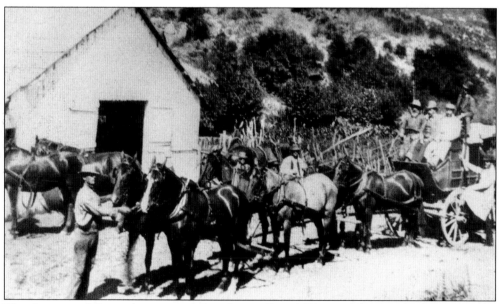

The changing of this six-horse team takes place at Patrick Kinevan's barn and tollgate near the top of San Marcos Pass. Norah Kinevan prepared a substantial meal and let drivers pay whatever they thought the meal was worth.

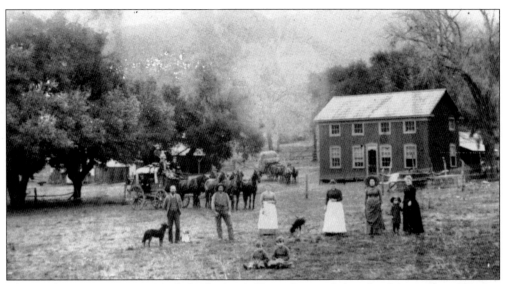

This mud wagon is seen at "Uncle Will" Step's Home Station below San Marcos Pass. Newton Bray, with the two dogs, was Step's brother-in-law. Also in the photograph are De Oakley, three stage passengers, and, in the foreground, Bertha and Alice Oakley.

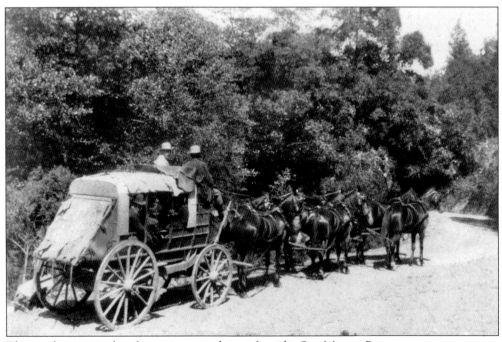

This mud wagon and six-horse team are depicted on the San Marcos Pass.

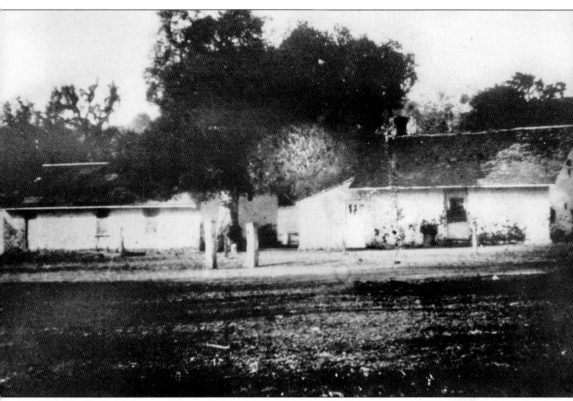

The Ballard Adobes and Stage Station were photographed here around 1870. The adobe at the left was first built by William Ballard. Numerous early Los Olivos residents lived in the adobes now owned by Alex and Dale Rossi. The adobes comprise Santa Barbara County Historical Landmark Number 20.

STAGE LINE
—FROM—
Los Olivos to Santa Barbara.

TIME TABLE:—Stage leaves Los Olivos at 7:00 a. m., Santa Ynez, 8:00 a. m., daily going South, arriving at Santa Barbara at 4:00 p. m. Stage leaves Santa Barbara at 8:00 a. m. daily, going North, arriving at Los Olivos at 5:00 p. m.

RATES OF FARE:—From Los Olivos or Santa Ynez to Santa Barbara, $4.00; round trip, $6 00. Los Alamos to Santa Barbara, $3 65. Santa Maria to Santa Barbara, $4.75. Nipomo to Santa Barbara, $5 10. Arroyo Grande to Santa Barbara, $5.55 San Luis Obispo to Santa Barbara, $6.30; round trip, $11.50. All other fares in proportion. One and one half cents per pound for excess baggage

Free 'bus between Los Olivos and Santa Ynez to Stage passengers. Good accommodation at Cold Spring Station. N. WINES, Manager.

The *Santa Ynez Argus* was one of the early newspapers in the Santa Ynez Valley. The advertisement here is from the September 20, 1894, edition. The *Santa Ynez Argus* was an organ for development companies. The 1894 editor was Harry Robinson.

Los Olivos-Santa Maria Stage
R. O. Walker, Proprietor, Orcutt
2 Round-Trips Daily

SCHEDULE

Leave Santa Maria 7:00 a.m.	Leave Santa Maria 4:00 p.m.
Arrive Los Olivos 8:50 a.m.	Arrive Los Olivos 5:45 p.m
Leave Los Olivos 9:00 a.m.	Leave Los Olivos 6:00 p.m.
Arrive Santa Maria 11 a.m.	Arrive Santa Maria 8:00 p.m.

All Stages Connect with Santa Barbara Stage

The July 13, 1917, edition of the *Santa Ynez Argus* is seen here.

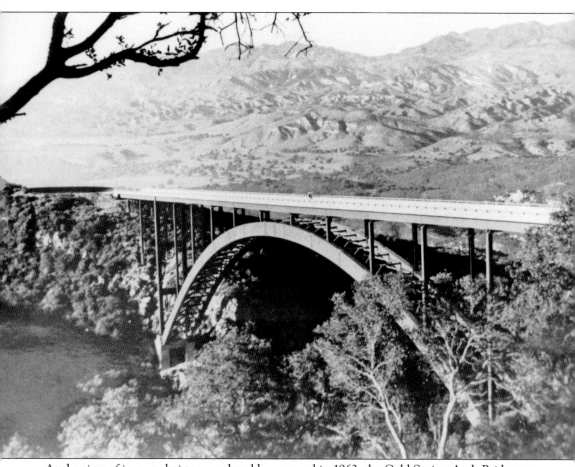

At the time of its completion over the old stage road in 1963, the Cold Spring Arch Bridge was the longest single-span bridge in the United States.

Four

PACIFIC COAST RAILWAY

The narrow-gauge railroad was gradually extended from Avila (also known as Port San Luis, Port Harford, and Avila Beach) through San Luis Obispo, Arroyo Grande, and, in 1882, Santa Maria to Los Alamos. In November 1887, Chinese roadbed workers and 600 track employees led by foreman Tom Donahue completed the line to Los Olivos.

All railroad companies, while working their way west across America, followed a similar pattern: acquire right-of-way by purchase or government incentive, start a "local" newspaper for publicity concerning the soon-to-arrive "paradise," build a hotel, offer very attractive fares, plat a town site, widely advertise a picnic or barbecue, and—hopefully—auction lots. All of the above hoopla was supported by railroad companies cooperating with one another nationwide.

Principles in the Pacific Coast Railway (PCRy) were J. Millard Fillmore, Nathan Goldtree, Capt. Charles Goodall, John L. Howard, Robert D. Jack, George C. Perkins, Chauncy Hatch Phillips, and Edgar W. Steele. Intertwined interests, including directorships, controlled the Santa Ynez Land and Implement Company (1883); West Coast Land Company (1886); Los Olivos Land Association (1887); Pacific Coast Steamship Company (1876); Pacific Coast Railroad, then Pacific Coast Railway (1881); and the Oregon Improvement Company.

The railroad experienced good years from 1883 to 1893, when it transported 100,000 passengers a year. The PCRy was, at first, underpowered and poorly built with light rail and sand ballast. An unexpected bumper crop of wheat and barley resulted in block-long stacks of bulging, 100-pound San Quentin grain sacks at each station, which overwhelmed the railway. With crops lining the tracks at each station, larger rail and engines were soon required. Engines were originally wood-burning, then coal, and finally oil.

Net earnings for the PCRy were $47,229 in 1909, $64,800 in 1910, $36,869 in 1911, and $59,764 in 1912. In 1912, some 63,319 passengers rode the line. The railroad was slow to convert to auto-coupler air brakes and was still changing over in 1912. A stationary night man "knocked the fire," removed clinkers over the pit, and moved the engine. Stock pens were built north of Grand Avenue in Los Olivos but were pulled out before 1930 because cattle transport was not profitable on the PCRy. Local boys often poured oil on the tracks so the drive wheels would slip going up the slight grade west of town and, much to the glee of the boys, the engineer would have to sand the track.

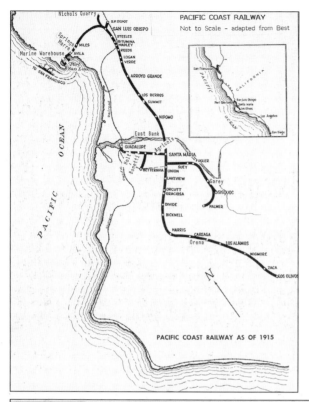

PACIFIC COAST RAILWAY AS OF 1915

This right-of-way drawing of the Pacific Coast Railway stations/stops also includes a 1913 timetable. The 65.8 miles from San Luis Obispo to Los Olivos was scheduled to take four hours—a whopping 17 miles per hour! The Santa Maria–to–Guadalupe route was an electric line.

PACIFIC COAST RAILWAY COMPANY

East Bound		FROM PORT SAN LUIS		MILES FROM PORT SAN LUIS	TIME TABLE NO. 37 MAY 4, 1913 STATIONS	MILES FROM LOS OLIVOS	CAPACITY OF SIDING IN CARS	TO PORT SAN LUIS		West Bound	
Second Class		First Class						First Class		Second Class	
8 Freight	6 Mixed	4 Mail & Express	2 Passenger					1 Passenger	3 Mail & Express	6 Mixed	7 Freight
Leave Daily	Leave Daily	Leave Daily	Leave Daily					Arrive Daily	Arrive Daily	Arrive Daily	Arrive Daily
	12.30 PM				⊳ PORT SAN LUIS W T	76.1	146			11.55 AM	
	12.32			0.3	⨍ HOTEL MARRE	75.8				11.53	
	12.37			2.0	⨍ AVILA	74.0	47			11.46	
	12.46			3.4	⨍ SPRINGS	72.7				11.30	
	12.50			4.0	⨍ MILES	72.1	19			11.35	
9.10 AM	1.10 PM	2.45 PM	6.30 AM	10.3	⊳ SAN LUIS OBISPO W C T	65.8	110	10.45 AM	2.30 PM	11.15 AM	6.05 PM
9.13		2.50	6.33	11.4	⨍ S. P. JUNCTION	64.7	18	10.41	2.13		
		3.05	6.45	12.1	S. P. DEPOT	65.4	12	10.36	2.10		
		3.08	6.48	11.4	⨍ S. P. JUNCTION	64.7	18	10.33	2.01		
9.30		3.20	6.59	15.9	⨍ STEELE'S	60.2	23	10.21	1.48		5.45
9.35		3.24	7.03	17.4	⨍ BITUMINA	58.7	60	10.17	1.44		5.40
9.45					⨍ HADLEY		22				5.35
10.03		3.38	7.17	22.3	⨍ VERDE	54.1	15	10.03	1.30		5.15
10.35		3.49	7.27	25.5	⊳ ARROYO GRANDE	50.6	91	9.53	1.19		5.00
10.55		4.02	7.40	30.1	⨍ BERROS	46.0	17	9.40	1.05		4.35
11.05		4.10	7.46	31.9	⨍ SUMMIT	44.2	12	9.33	12.56		4.25
11.15		4.18	7.54	34.7	⊳ NIPOMO W	41.4	30	9.26	12.50		4.18
11.55		4.40	8.20	41.7	⊳ SANTA MARIA W	34.4	94	9.05	12.30		3.50
12.01 PM		4.42	8.25	43.4	SUEY JUNCTION y	32.7		9.00	12.17		2.50 PM
		4.46		43.7	⨍ UNION	32.4			12.15		
		4.53	8.33	45.7	⨍ LAKE VIEW	30.4	16	8.54	12.10		
		5.04	8.38 AM	48.0	⊳ ORCUTT	28.1	40	8.48 AM	12.05		
		5.06		48.5	⨍ GRACIOSA c	27.6	10		11.59		
		5.14		50.6	⨍ DIVIDE	25.5	14		11.44		
		5.23		52.6	⨍ BICKNELL	23.5	10		11.34		
		5.33		55.0	⨍ HARRIS	21.1	19		11.34		
		5.45		58.4	⨍ CARREAGA	17.7	8		11.10		
				60.4	⨍ ORENA	15.7	8				
		6.07		63.8	⊳ LOS ALAMOS W	12.3	24		10.52		
					⨍ WIGMORE				10.37		

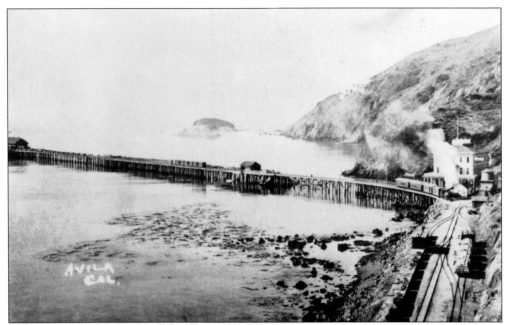

An aerial view of the PCRy complex at Avila shows the Marre Hotel and the pier with a warehouse at the end. The water was deep at the end of the pier, allowing company steamers and freighters to tie up. The present-day Olde Port Inn and fish marketplace are housed in the former warehouse. (Canet-Martin.)

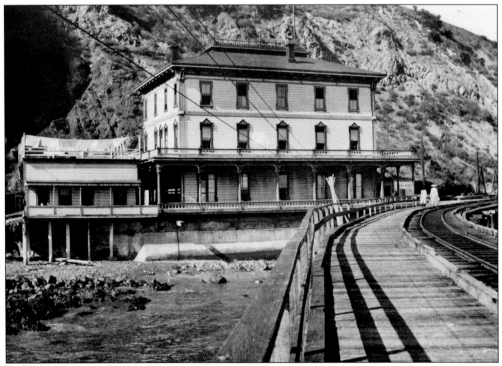

At the bend of the railway pier at Avila Beach stood Luigi Marre's hotel. The hotel burned down later. The Marre family in Avila is related to the Santa Ynez Valley Marres.

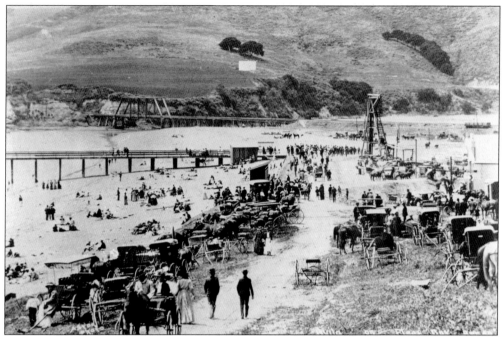

This is a photograph of Fleet Day, April 30, 1908, in Avila Beach. Occasional PCRy excursion rides from Los Olivos allowed Santa Ynez Valley residents a cool day at the beach. The Pacific Coast Railway track and bridge are seen at the top of the photograph. (Canet-Martin.)

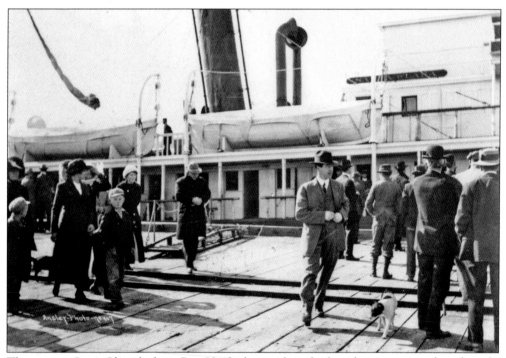

The steamer *Santa Clara* docks at Port Harford, providing shipboard transport north and south. Everyone but the dog is well turned out. (Canet-Martin.)

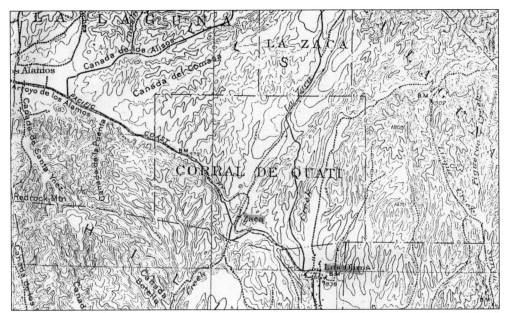

The Pacific Coast Railway right-of-way is traced here from Los Alamos to Los Olivos. (U.S. Geological Survey.)

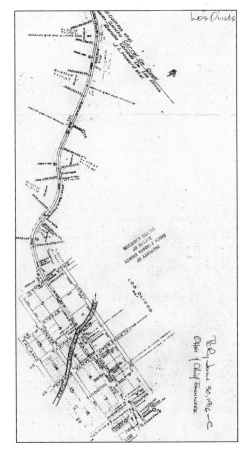

Here is the 1916 plat of the PCRy's Los Olivos survey by the Office of the Railway Chief Engineer. The warehouse, station, roundtable, and bridges are noted. In 1902, when oil gushers came in, the line had no tank cars, so they were jury-rigged on flat cars. Some railway notations include these, from July 18, 1888: "Los Olivos 190' x 40' warehouse almost completed"; and September 27, 1888: "PCRy is called 'Wheelbarrow Road.'"

Pacific Coast Railway
(Owned and operated by Pacific Coast Co.)

—BETWEEN—

Port Harford, San Luis Obispo, Santa Maria, Los Alamos and Los Olivos

E. W. CLARK, Supt., San Luis Obispo, Cal.

From PORT HARFORD South First Class		Miles from Port Harford	STATIONS	Miles from Los Olivos	To PORT HARFORD North First Class	
Passenger Daily	Mail and Express Daily				Mail and Express Daily	Passenger Daily
A.M.	p.m.				A.M.	p.m.
9 00	2 00	.0	Lv..Port Harford....Ar.	76.1	8 20	11 50
9 02	2 02	0.3	*Hotel Marre	75.8	8 18	11 48
9 06	2 07	2.1	*Avila	74.0	8 13	11 43
9 11	2 14	3.4	*Sycamore Hot Sulphur Springs	72.7	8 09	11 36
9 13	2 17	4.0	*Miles	72.1	8 07	11 33
9 30	2 40 / 5 45	10.3	San Luis Obispo	65.8	7 50 / 7 35	11 15
	5 50	11.4	*S. P. Junction	64.7	7 29	
	5 55 / 6 05	12.1	S. P. Depot	65.4	7 25 / 7 20	
	6 07	11.4	S. P. Junction	64.7	7 18	
	6 21	15.9	*Steele's	60.2	7 04	
	6 26	17.4	*Rock Siding Three	58.7	7 00	
	6 30	19.3	*Reed's	56.8	6 55	
	6 39	22.0	*Verde	54.1	6 48	
	6 52	25.5	Arroyo Grande	50.6	6 36	
	7 06	30.1	*Los Berros	46.0	6 20	
	7 11	31.9	*Summit	44.2	6 14	
	7 20	34.7	Nipomo	41.4	6 05	
	7 42	41.7	Santa Maria	34.4	5 44	
	7 52	45.7	*Lake View	30.4	5 30	
	8 01	48.5	*Graciosa	27.6	5 23	
	8 08	50 6	*Divide	25.5	5 17	
	8 14	52.6	*Blake	23.5	5 11	
	8 22	55.0	*Harris	21.1	5 05	
	8 46	63.8	Los Alamos	12.3	4 41	
	8 59	67.8	*Wigmore	8.3	4 29	
	9 05	70.1	*Calkin	6.0	4 23	
	9 13	72.8	*Zaca	3.3	4 15	
	9 25	76.1	Ar..Los Olivos....Lv.		4 05	

* Stop on signal to receive passengers or freight.

Connections at Port Harford. Train leaving San Luis Obispo at 7:50 A.M., and arriving at Port Harford at 8:20 A.M., connects with steamers Santa Rosa and Corona bound south, and steamers Orizaba and Coos Bay bound north. Train leaving San Luis Obispo at 11:15 A.M. connects with steamers Santa Rosa and Corona bound north, and steamers Orizaba and Coos Bay bound south. Passengers on board steamers Santa Rosa and Corona, north bound, desiring to spend nearly two hours in the ancient and interesting town of San Luis Obispo where the Mission erected in 1772 still stands in a good state of preservation, can secure at the ticket office at Port Harford round trip excursion ticket for 50 cents, good only on date issued. The ride from Port Harford to San Luis Obispo, a distance of ten miles, is very interesting. The Sycamore Hot Sulphur Springs are also passed, situated about four miles south of Port Harford. Train leaves Port Harford at 9:00 A.M., returning leaves San Luis Obispo depot at 11:15 A.M., connecting with steamer.

Connections at San Luis Obispo, daily, with Southern Pacific Co., for El Paso de Robles Springs, Paraiso Hot Springs and San Francisco and with stages from San Luis Obispo for Moro, Cayucos and Cambria. At Los Olivos, daily, for Santa Ynez and Santa Barbara.

The January 1899 PCRy timetable lists 27 stations and flag stops. At Los Olivos in 1887, there was a two-engine shed, turntable, station, warehouse, loading dock, corrals, lumber sales, windmill, and sidings. Later Kenny Cornelius would frequently show off by doing handstands on the water tower. Kids were sometimes allowed to fill the engine with water, which took 20 minutes.

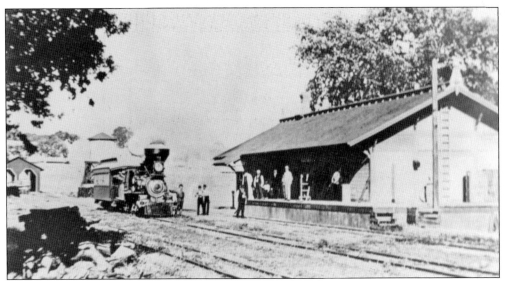

Los Olivos Station is shown with Engine No. 2 and John Harford. No. 2 was a Baldwin 4-4-0 No. 3968, built in 1876 and weighing 44,000 pounds. To the east are the engine house, water tank, triple track, and loading dock. (Bennett-Loomis.)

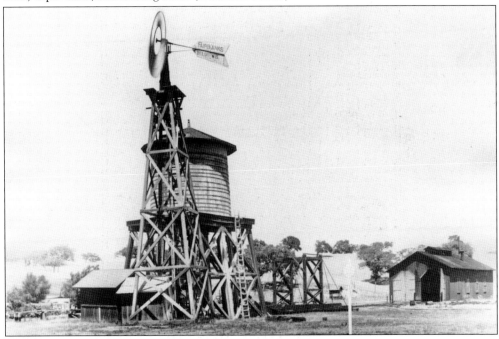

This *c.* 1890 view depicts Los Olivos at Grand Avenue. Looking northeast, the railroad track, water tank, windmill, and two-stall engine house can be seen. Perhaps the greatest tragedy associated with the railroad in Los Olivos happened around this time. Depot agent Fred Hoar was anticipating his 1893 wedding to a Miss Weston of Boston when he was murdered by two bandits. The culprits, John Ward and Harry McLaughlin, were captured by a posse near Santa Rosa Road. Sheriff James Donahue returned them to Los Olivos for identification, then took them to jail in Santa Barbara. Both men were convicted and served long sentences in San Quentin. (Bennett-Loomis.)

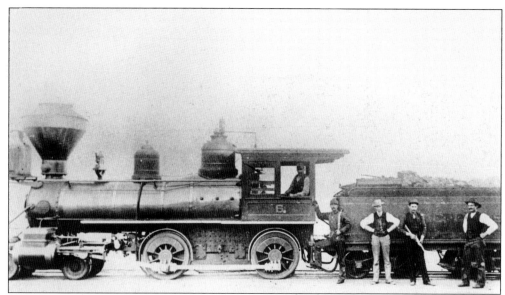

Seen in 1890 is coal-burning engine No. 6, Baldwin 4-4-0 No. 6921, built in 1883 and weighing 43,000 pounds. This engine burned in the Los Olivos engine house on July 12, 1896.

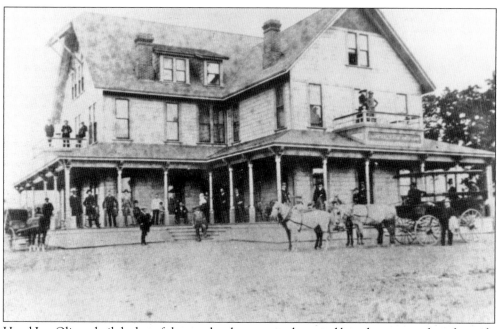

Hotel Los Olivos, built by hopeful town developers, was destroyed by a devastating fire after only two years in existence. Approximately 50 guests are posing for the photographer. Designed and constructed by William Evans, the hotel was completed on May 1, 1888. It was three stories high and offered 60 rooms, including reading and billiard rooms. The cost was $15,000, plus another $5,000 to furnish it. W. C. Davis was the first manager, and then it was managed by O. M. Brennan. Bricks and burned silverware are occasionally found at the site.

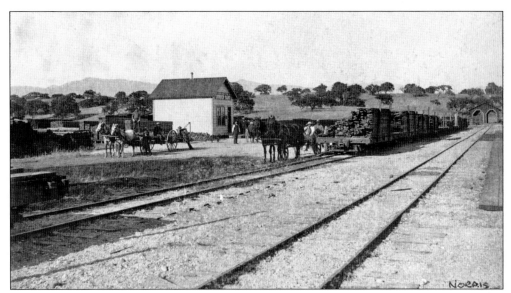

Los Olivos Pacific Coast Railway lumberyard is depicted around 1900, looking east, showing the double engine house. The first agent was named Stone. Lumber for early Santa Ynez Valley homes and, later, for buildings in Solvang came from this yard. This engine house and Engine No. 6 were destroyed by fire; the engine house was later rebuilt.

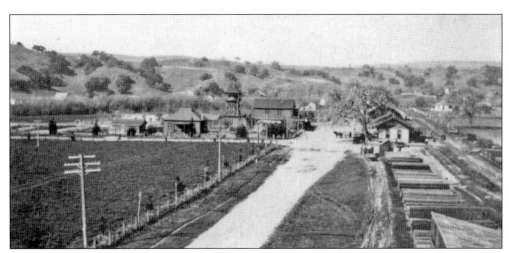

The Los Olivos Railroad lumberyard is seen here in a westward view. The railroad could carry lumber up to 36 feet long. Mattei's Tavern and the two cottages to the south had been painted a bilious green. (Howard Sahm.)

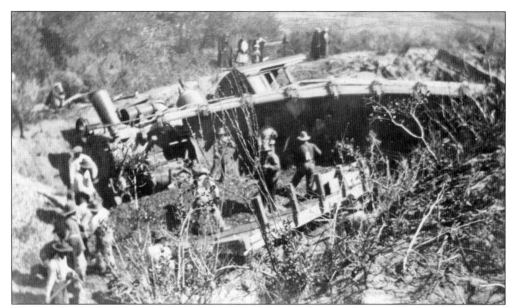

The wreck of Engine No. 110 at Nipomo is seen in this photograph. It is not known when this accident occurred, but no one was killed.

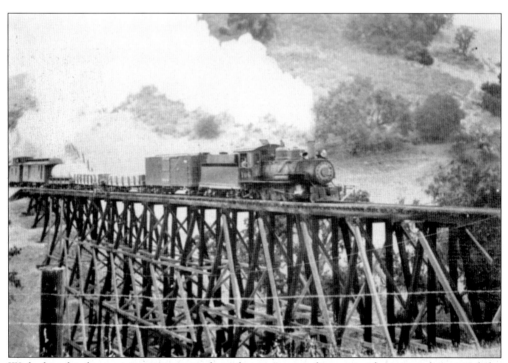

With the whistle announcing its arrival at "the cut," west of town, residents eagerly awaited the train and its baggage-mail car. Engine No. 106 is seen here, crossing the trestle at what is now the junction of Highways 154 and 101. Engine No. 106 was destroyed by fire in 1938. As one travels west, leaving Los Olivos on today's Highway 154, one can see the roadbed on the side of a hill.

The Pacific Coast Railway's Fairbanks Morse scales were located across from Mattei's Tavern. George Clark ran the scales. Felix Mattei is on the right, and his sons are sitting on the scale.

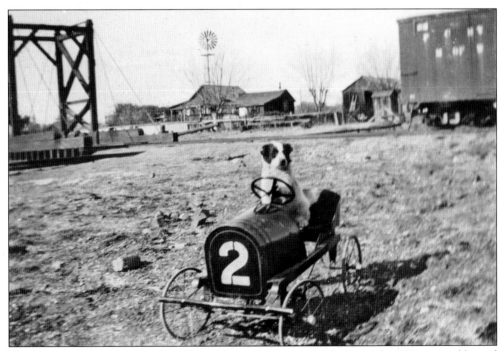

This westward view includes a local dog posing as the driver of "Ol' No. 2," the PCRy turntable, and a freight car on the siding, as well as the Campbell home and a windmill in the background.

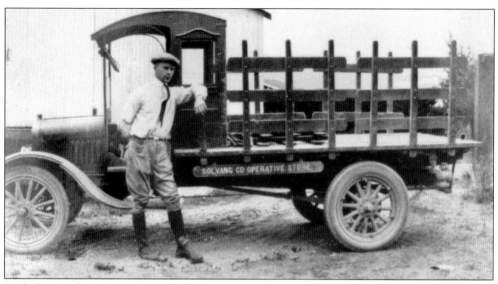

Each day, Emil Andersen drove the Solvang Co-operative Store truck to Los Olivos to pick up orders at the station. He timed his arrival so he could ride with the engineer as he moved cars.

STATE OF CALIFORNIA

Public Weigh Master's Certificate of Weight and Measure

N⁰ 7414

LOS OLIVOS, CAL. STATION 6/27 191 7

WEIGHED FOR A Collis CARRIER

THIS IS TO CERTIFY that the following described merchandise was weighed by a Public Weigh Master, and the seal hereto attached is a recognized authority of accuracy, as prescribed by Chapter 653, California Statutes, 1915:

THIS CERTIFICATE IS NON-NEGOTIABLE

GROSS 71.80

TARE 3820

NET WEIGHT 8860

UNITS COMMODITY

MARK DATE WEIGHED 6/27

SEAL DELIVERED TO

PACIFIC COAST RAILWAY COMPANY

By

PUBLIC WEIGH MASTER

This is a 1917-vintage waybill to Los Olivos. The Collis farmed leased land north of the tavern belonging to Felix Mattei.

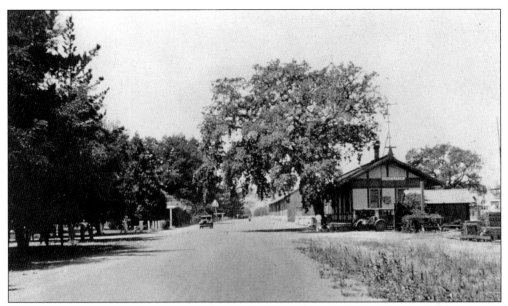

Los Olivos Station is seen in a westward view toward Mattei's Tavern.

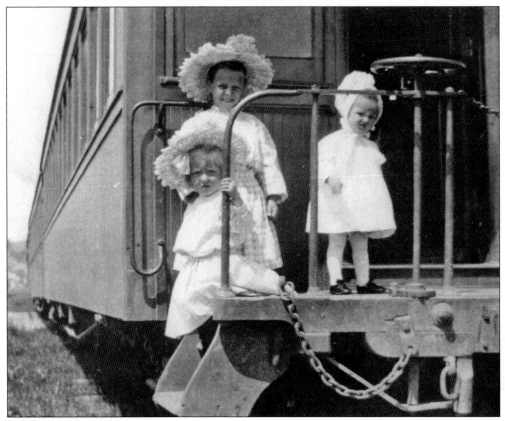

The Davis children were photographed at the Los Olivos Station. Contrary to an oft-repeated tale, the PCRy was probably never built to be converted to a standard gauge railway, nor were there plans for it to be purchased by the Southern Pacific Railroad. (Dot Wolford.)

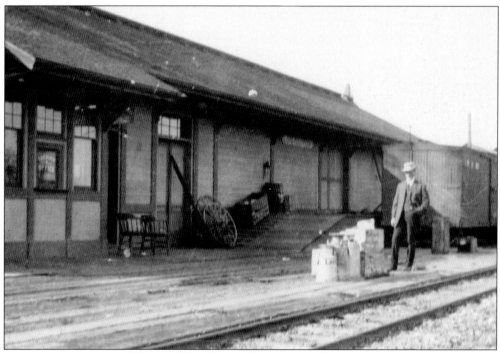

Postal railroad worker Will Schneider is depicted at the Los Olivos Station loading dock. Cream is waiting to be loaded.

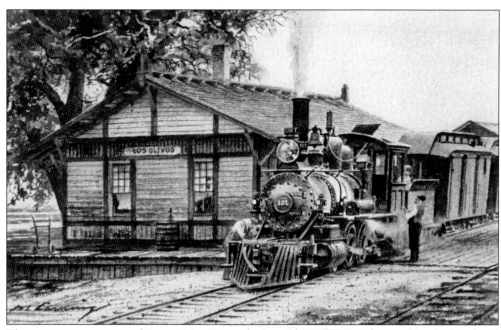

This is a representation of Engine No. 101 at the Los Olivos Station, depicted by the late local artist Merv Corning. (Tula Corning.)

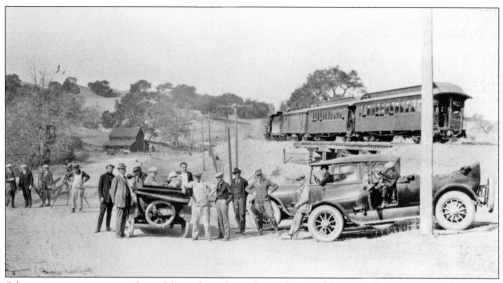

Silent movie crews moved quickly and easily without the need for sound equipment. This movie is being filmed in Los Olivos around 1923. In the background is the extant barn of George Smith. The railroad bed seen here is still visible driving west from Los Olivos.

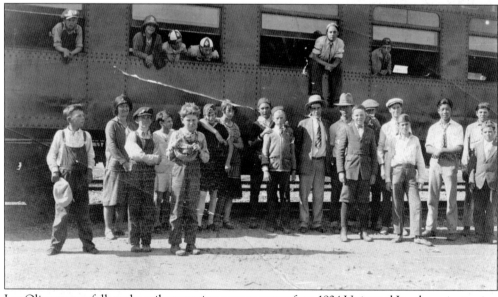

Los Olivos townsfolk at the railway station pose as extras for a 1924 Universal Jewel movie starring Reginald Denny. Overalls were more typical than knee pants. Ties and hats are movie wardrobe additions. (Allyn Martin.)

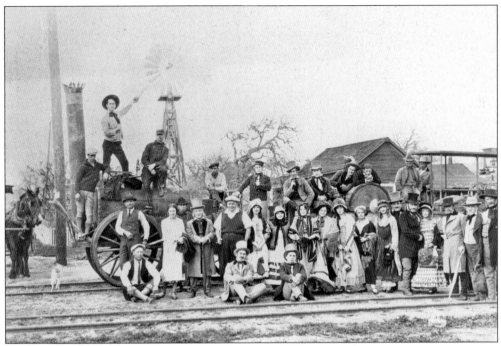

The 1935 Universal movie *Diamond Jim* is shown being filmed on PCRy tracks. The film starred Edward Arnold, Jean Arthur, and Cesar Romero. (California State Railroad Museum.)

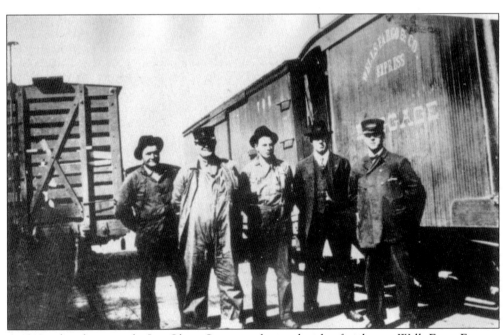

A 1912 railroad crew at the Los Olivos Station is depicted with a freight car, Wells Fargo Express baggage, a mail car, and a boxcar. Pictured from left to right are unidentified, Bruener, Harry Rice, Joe Martin, Fred Lang, and station-master Andy Ward. Fred Lang worked for the PCRy for over 20 years, serving as an engineer, conductor, baggage man, brakeman, and express messenger.

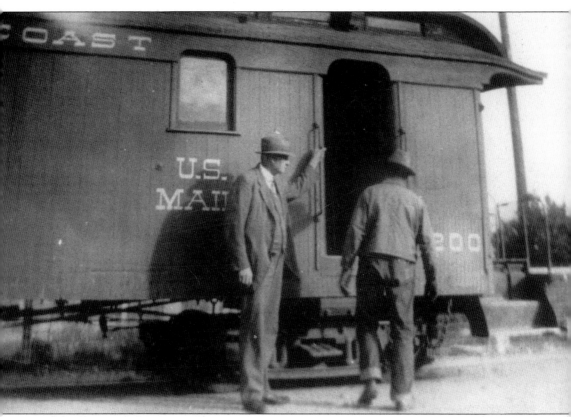

Engine No. 106 at the Los Olivos Station is seen in 1934 with the crew of last train on the line. Local rancher Ted Chamberlin is about to board mail-baggage car No. 200 assisted by Bill Schneider. Schneider always wore a suit and hat and was a railway postal clerk from 1902 to 1934. Ted Chamberlin arrived in Los Olivos in 1929, where and when he met and married local high school teacher Ailie van Loben Sels. He was an important political influence in the Santa Ynez Valley. Over the years, local agents and employees of the Pacific Coast Railway included G. Allwein (1919), Scott Bert (1908), Joe Brown (1895–1934), William H. Brown (1910), John W. Browning (1925), "Terry" Browning (1925), John P. Bruener (1910–1912), J. B. Burkett (1888–1889), J. W. Calkins (1888), ? Carey (1916), Jim Cheeney, Chris Christiansen (1895), Neil B. Christiansen (1884–1934), George W. Clark (1894–1934), J. S. Clark (1889), Leon Cooper (1937), Roy Cooper (1937), George B. Cullen (1889–1890), "Chet" Dailey (1905), Bernard B. Davis, Joe DeLaney (1893), L. W. DePug (1917), ? DeVaul, Jim Donahue (1886), Allen Downs, Sheb Downs, Hugh H. Doyle (1885–1895), Don Farmer (1909), George Farmer (1886–1910), ? Fordyce, Charlie Fouts, Glenn L. Fretwell, ? Frost (1934), ? Gallivan, L. W. George (1917), Jesse Alvin Gruell, Front Hampton (1904–1934), Louis P. Hartley, A. W. Hawkins (1895), E. G. Hayne (1888–1893), Fred Hoar (1893), Henry Holland (1887), Richard W. Holland (1887), Charles F. Kendall (1896), John King (1900), Fred Lang (1912–1933), A. John Locke, Joe Martin (1912), J. H. Mathews (1908), A. M. McCurdy (1889–1934), Mark Meherin (1915), I. N. Moses (1889–1893), "Lupe" Munoz, Ferrill C. Nickle (1899–1910), Manuel Parades, Addison A. Patterson (1887–1896), Harley Ragle. ? Replogle, Harry Rice (1910–1912), Isaac Sahm, William H. Schneider (1902–1934), J. H. Sims (1888–1935), Frank M. Smith, ? Stone (1889), J. J. Stratton (1892), ? Symmes (1889), Dewey Tunnell (1907–1910), Fred F. Tunnell (1896), Colonel Von Schmidt (1886), H. R. Wade (1908), Andrew E. Ward (1893–1934), Orean Ward (1901–1910), Fred Warner (1910), Hugh C. Washburn, H. W. Welle (1887), T. J. Williams (1887), ? Willitt, Harold Wollam (1929–1934), and A. W. Wood (1892). (Peggy Vernor.)

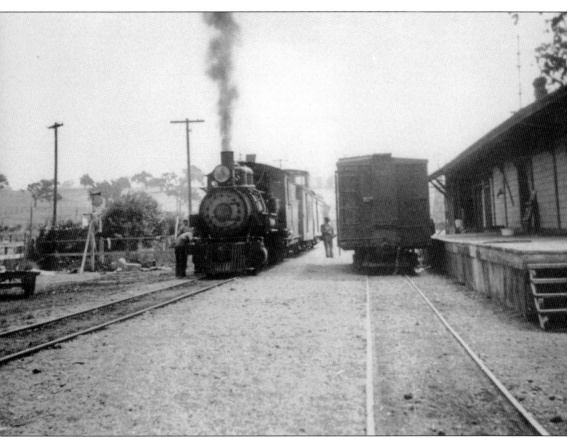

In 1934, the last train pulled out of Los Olivos. This was Engine No. 106, a 73,000-pound Baldwin 2-8-0 model built in 1904, No. 23968. It pulled an oil tank car, caboose, passenger car, and a baggage-mail car. The engineer was Fred Lang, and the baggage-mail clerk was 7-foot-tall William Schneider. Townsfolk rode as passengers to Zaca Station, where they disembarked. The warehouse was later torn down by the Cooper brothers and used to build Roeser's Feed Store in Solvang. The rails were pulled up and the ties used by local ranchers for fencing. The Los Olivos Station was torn down, and the Cooper brothers used the lumber for the construction of a home on Figueroa Mountain Road.

Five

MATTEI'S TAVERN

An acclaimed tradition since 1886, Mattei's Tavern is the oldest continually operating restaurant in the Santa Ynez Valley. In Santa Barbara County, it is second only to one, Santa Barbara's Lincoln-Upham Hotel. Mattei's names over the years include Central Hotel, Los Olivos Hotel (1890), Hotel Los Olivos, Stage Coach Inn, and, finally, Mattei's Tavern.

Felix Mattei, his wife, Lucy (Fisher) Mattei, and his brother, Louis, lived in the Huasna, east of Arroyo Grande, in 1884 before they moved with Felix and Lucy's five sons to Los Olivos. Felix had also managed a hotel in Cayucos and had been a partner with the Goldtree brothers of San Luis Obispo in the $5,250 sale of a ranch in Guadalupe. Felix raised horses, and while driving his remuda to a sale in Los Angeles, he passed through Los Olivos and noted its development possibilities.

Born in Switzerland in 1854, cosmopolitan Felix spoke several languages. It was no accident that he arrived in Los Olivos just before the railroad and that he knew of the stage stop at the Ballard Adobes.

He constructed a tent hotel, opened a restaurant, and then built a seven-room, two-story hotel. In July 1892, the tavern's size was doubled (and has been expanded and remodeled several times over the years). Lucy cooked for the restaurant, and later two Chinese cooks were employed. Los Olivos was a sportsman's paradise, and the Chinese cooks were adept at preparing the fresh game: duck, geese, deer, and clams from Pismo Beach. Local youngsters were hired to catch steelhead trout in the Santa Ynez River, which Felix served free to avoid game law violations.

Contrary to local lore, the tree across the road from Mattei's was never used for a hanging, and even though Lucy was a member of the local Women's Christian Temperance Union, liquor was always available, particularly for the annual meetings of the Los Alamos Society and the Rancheros Visitadores. During Prohibition, it is possible the booze was hidden, but it was always available.

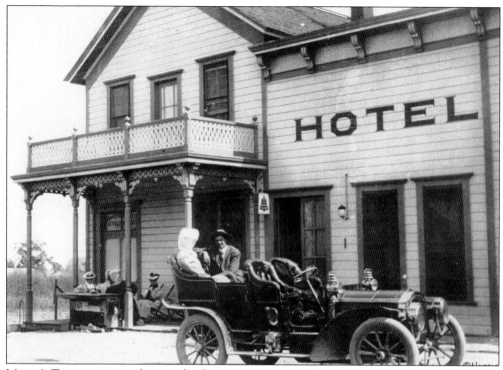

Mattei's Tavern is currently open for dinner. Visitors in earlier times, sometimes motor-touring with a chauffeur, were offered lunch, dinner, and an overnight stay in one of the small upstairs bedrooms or in one of the cottages on Nojoqui Avenue.

After the three additions to the two-story hotel were made, the east room was closed, becoming what was referred to for many years as the "Wicker Room." The signage is courtesy of Bell Telephone. The original stage barn is just visible to the west.

The Automobile Club (of Southern California), in its 1915–1916 touring guide, listed Mattei's Tavern and the Los Olivos Garage as destinations. Included was this advertisement for the tavern. Among the staff over the years were the brothers Gustavo "Gus" and Charles Berg, while folk artist Ernie G. Walford from England via Australia tended the flowers and garden for 34 years. Early Mattei's self-sustaining aspects included a garden, fruit trees, dairy and cheese house, and a well. Soft water, brought by wagon from an artesian well in Crawford Canyon, was offered to the ladies for bathing and shampooing. West of the tavern, a family cottage was built and, in 1975, became Dr. Louis Netzer's Mellow Country Clinic. In 1983, Drs. Bob Gottesman, Alan Hersh, and Jeff Shannon leased the building as the Country Clinic.

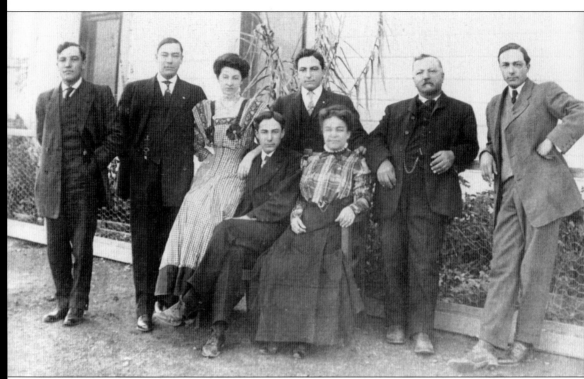

Few photographs of the entire family exist. From left to right are (standing at the side of the tavern) Clarence, Fred, Elaine (Fred's wife), Charles, Felix, and Frank; (seated) Albert "Bert" and his mother, Lucy. Felix and Lucy Mattei had five sons: Frank O. (1880–1931) married Laura ?; Fred L. (1881–1962) married Elaine Spaulding; Clarence R. (1883–1945) married Millie Crittendon in London and later Merle (Gossett) Wilhoit; Charles C. (1886–1961) married Lorraine Hanneman; and A. C. "Bert" (1895–1969) married Ferne Orchard. There were no natural male heirs, but Bert and Ferne adopted a son, Peter, and Charles and Lorraine had a daughter, Suzanne.

Fred and Elaine are seen shortly after their wedding. A honeymoon of touring through California's scenic north followed.

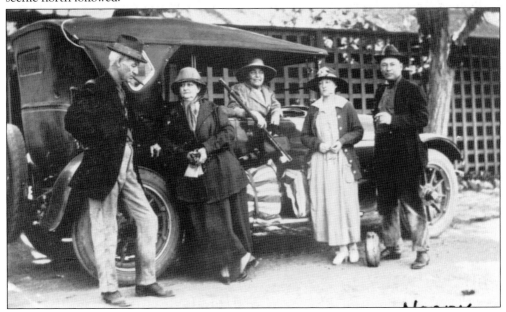

From left to right are Elaine's parents, the Spauldings; Lucy Mattei; and Elaine and Fred Mattei. The Spauldings were grain dealers in Woodland, California, and Fred, after his marriage to Elaine, worked for them.

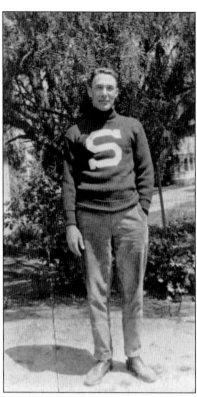

Bert Mattei attended Stanford University, where he majored in geology. He eventually became president of the Honolulu Oil Company and was a confidant of Pres. Herbert Hoover.

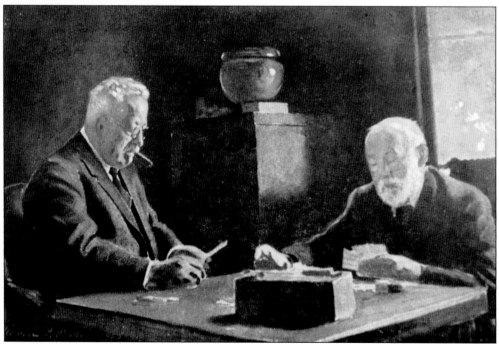

An evening ritual was cigars in the tavern while Felix Mattei and Gus Berg (1845–1937) played pinochle. This is the noted painting *Pinochle Players* by Felix's son, Clarence Mattei. It was entered in a Los Angeles competition. Notice Gus's hands are unfinished.

The railway employed many Chinese workers while developing the right-of-way and laying track. In 1887, after the station was completed in Los Olivos, many were hired as local ranch cooks. Gin Lung Gin (1871–1947), born in Goleta, was a longtime cook at Mattei's, where he was famous for his game recipes and, to local children, for lace cookies. He lived in a small room behind the tavern. Gin always talked of his birthplace, but he never traveled to China, where he had a family. He is buried in a Mattei plot at the Oak Hill Cemetery in Ballard.

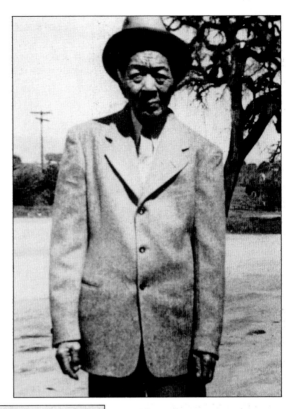

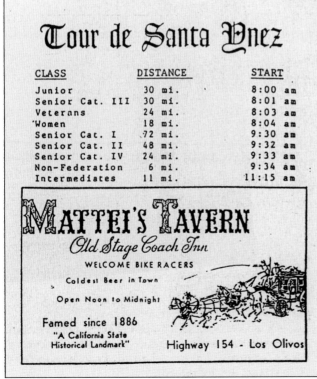

Tour de Santa Ynez

CLASS	DISTANCE	START
Junior	30 mi.	8:00 am
Senior Cat. III	30 mi.	8:01 am
Veterans	24 mi.	8:03 am
Women	18 mi.	8:04 am
Senior Cat. I	72 mi.	9:30 am
Senior Cat. II	48 mi.	9:32 am
Senior Cat. IV	24 mi.	9:33 am
Non-Federation	6 mi.	9:34 am
Intermediates	11 mi.	11:15 am

MATTEI'S TAVERN
Old Stage Coach Inn
WELCOME BIKE RACERS

Coldest Beer in Town

Open Noon to Midnight

Famed since 1886
"A California State Historical Landmark"

Highway 154 - Los Olivos

When the tavern was owned by Bud New in 1967, he anticipated many of the activities for which Los Olivos would later become noted—bicycle touring (Tour de Santa Ynez), balloon rides, wine-tasting, and artists and musicians in residence. With a return to the hospitality offered by Felix Mattei, locals and tourists were always welcomed by Bud, often at the bar with a gin martini in hand.

61

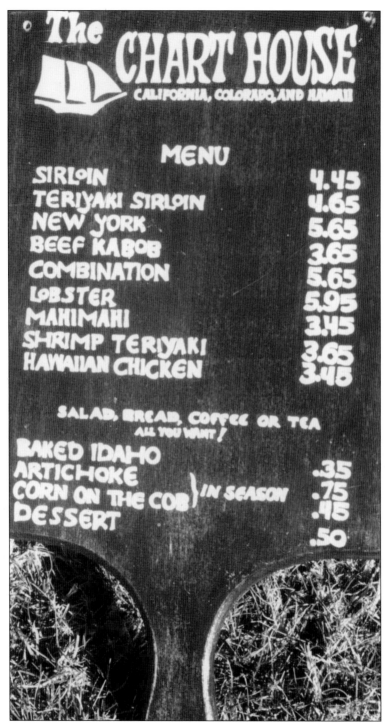

The CHART HOUSE

CALIFORNIA, COLORADO, AND HAWAII

MENU

SIRLOIN	4.45
TERIYAKI SIRLOIN	4.65
NEW YORK	5.65
BEEF KABOB	3.65
COMBINATION	5.65
LOBSTER	5.95
MAHIMAHI	3.45
SHRIMP TERIYAKI	3.65
HAWAIIAN CHICKEN	3.45

SALAD, BREAD, COFFEE OR TEA
ALL YOU WANT!

BAKED IDAHO	.35
ARTICHOKE	.75
CORN ON THE COB } IN SEASON	.45
DESSERT	.50

Mattei's Tavern experienced a progression of owners, operators, and remodeling after the death of Fred Mattei in 1962. After Bud New's ownership, the Chart House (a theme restaurant) operated the tavern from 1973 to 1986. Note the prices. It is now the Brothers Restaurant at Mattei's Tavern.

Six

THE TOWN AND THE RESIDENTS

Los Olivos was platted in 1887, and the Chinese who worked on the railroad roadbed also graded the Los Olivos streets. Chauncy Hatch Phillips and E. W. Steele of the West Coast Land Company conducted the first lot sales, and though the sale was well-attended, offering an enticing barbecue, possible buyers remained on the train because of a drenching rainstorm.

Phillips, a consummate salesman, was also involved in the development of Templeton, Cayucos, and Los Alamos. He was an important person on the Central Coast, and many of his 13 daughters married into prominent families.

The first Los Olivos post office opened on December 22, 1887, with Frank M. Smith as postmaster. Early homes were, predominantly, balloon-walled and constructed on the west side of town.

Itinerant salesmen (drummers) displayed their wares at Mattei's, and mail arrived on the railroad. When the telegraph became available at the station, ranch orders could be filled within several days, and it was no longer necessary to purchase 100-pound sacks of staples. Catalog sales became the norm. (Used catalogs were recycled in the outhouse.)

The railroad and stage employees had hard money, while most of the townspeople bartered with local businessmen. A few examples of housing supplied for employees of the railroad remain today—easily recognizable square buildings with eight-foot ceilings.

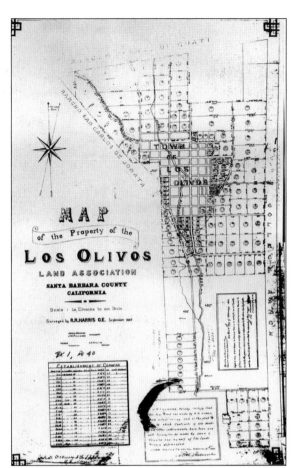

Los Olivos and vicinity are depicted in this 1888 rendering.

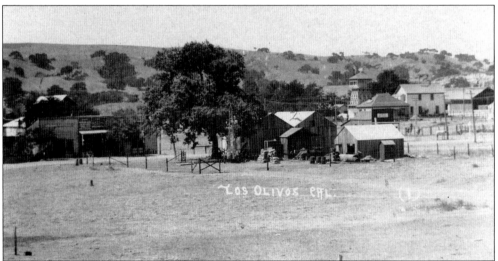

Early photographers produced panoramic postcard views. Above is a 1900 image of downtown Los Olivos showing, from left to right, D. D. Davis's warehouse and store, Stonebarger's Foundry complex, Mattei's Tavern including the water tower and one cottage, and the Pacific Coast Railway warehouse.

Rancho de Los Olivos belonged to Alden March Boyd. The balloon-framed, redwood house was built for Boyd by A. D. Smith. In 1991, the 1938 addition was separated from the original two stories, and both were moved to Los Olivos and rejoined. Exterior and interior architectural features were saved to maintain the original integrity. (Garrett Van Horne.)

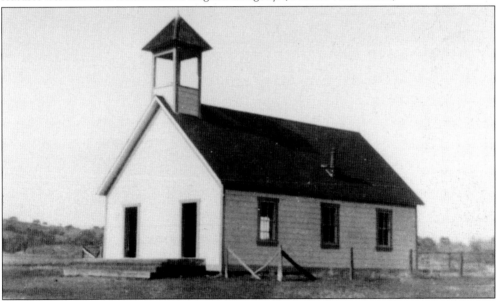

This church was constructed in 1894 by a quintet of men who came to Los Olivos from Indiana in 1888: A. William Davis, F. J. Van Etten, John Hartley, Tom Davis, and John Sides. Known then as the First Church of Christ, it has been the Berean Baptist Church for many years. The first church service was held in October 1894. The congregation was separated, with the men using one door and sitting on the right side of the church, while the women used the other door and sat on the left. The church has been in continual operation since its completion. Rev. Frank Whitmore has been pastor for many years. There was no undertaker, but custom suggested the body of the deceased be held in his or her parlor for a week for viewing. Burial took place on ranch plots or at Oak Hill Cemetery in Ballard. The church is Santa Barbara Historical Landmark No. 20. (Mrs. Carl Campbell.)

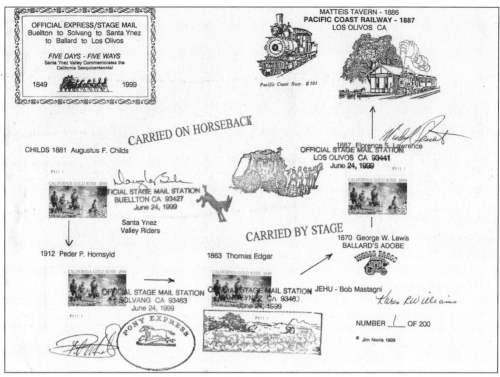

In June 1999, to commemorate the California Sesquicentennial, the author organized a horseback and stage mail delivery starting at Buellton and ending at Mattei's Tavern in Los Olivos. Each postmaster in turn used a historic cancel and resacked and locked the mailsack. Bob Mastagni was the stage driver.

POSTMASTER	BUILDING	DATE
Frank M. Smith	?	December 22, 1887
Florence L. Lawrence	Henning	April 14, 1888
Murdered by pharmacist husband		
Martin Brady	Davis	December 5, 1890
Emile Heymann	Davis	December ?, 1891
Frank L. Whitcher	Whitcher	March 15, 1898
Charles L. Whitcher	Whitcher	June 5, 1910
Clara M. Whitcher	Whitcher	March 6, 1915
Charles L. Whitcher	Whitcher	December 20, 1915
Bertha Anet (Kline) Libeu	Luton-Libeu	April 3, 1916
Etelka Downs	Downs	September 5, 1918
16 years as postmaster		
Ramona P. Lansing	Uncle Tom's	July 1, 1934
Moved to Los Alamos		
Nellie Stonebarger	Uncle Tom's	January 31, 1946
Amanda Meisgeier	Down's > present	February, 1961
Carl Noddin	Present	January, 1962
Mike Stewart	Present	October, 1986
Lori Oakley	Present	July, 2003

Lori Oakley was installed as Los Olivos's postmaster on July 16, 2004. She inherited a tradition in Los Olivos dating back to 1887

Frank and Cremora Whitcher ran the Staple and Fancy Grocery Store in Los Olivos. Mail was transported from the front to the back of the store in a small car, which ran on a homemade track. Using a Rochester Kerosene Big Light, the interior of this store was much brighter than was typical for the era. Frank and Cremora had four children: Charlie, Maynard, Clara, and Lottie. Clara married Isaac Sahm, and Lottie married George Chester, a teacher at Los Olivos School. Charlie, in partnership with his dad running cattle and hogs, was also a taxidermist who kept a stuffed condor on the premises and later collected specimens for the Smithsonian.

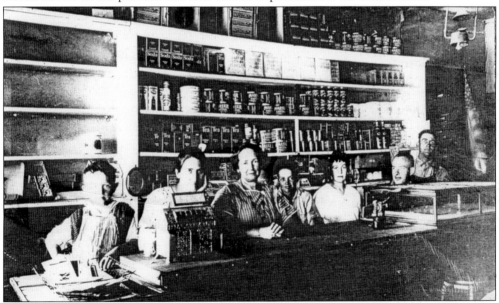

Campbell Grocery Store and Pool Hall was a Los Olivos mainstay. Pictured from left to right are Roy, Addie, Dell, Bob, and Viola "Peach" Campbell and two unidentified persons. Several items that were sold are recognizable: cigarette paper, tomatoes, a pound of Schilling's Best Soda, Schilling's Best Tea, Kellogg's Toasted Corn Flakes, Best Corn Starch, ER Durkee, Peralta crab and squab soups, sardines, and Master Coffee. Visible signs are Chesterfield's, advertised by the tagline, "They Satisfy and They are Mild," and "Fatima, a Sensible Cigarette." Carl Campbell, Dell's spouse, tore the building down and used the lumber to build, on site, the three still-existing cottages.

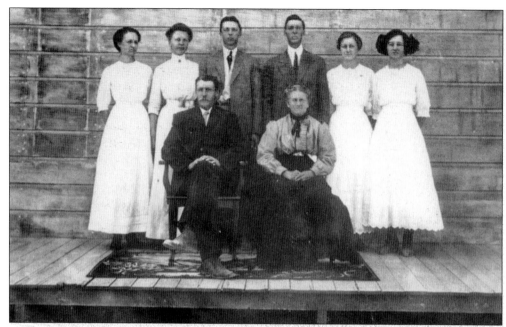

This portrait of the William "Will" Laine Davis family was taken around 1912. Will Davis married Lydia A. Garrison in Indiana in 1873. From left to right are (seated) Will and Lydia; (standing) Etelka, Keturah, Dallas Denver, Bernard Benjamin, Nora, and Della. Keturah married Carl C. Campbell; Etelka married William H. Downs; Dallas married Mayme Ray Dailey; Bernard married Martha Luella Cox; Nora married George G. Bartlett; and Della married Charles Emerson. The Davis family in Los Olivos is related to the following local families: Beattie, Buell, Campbell, Colombo, Downs, Fitzgerald, Gott, Hartley, Palmer, Parr, Payne, Troup, and Wolford.

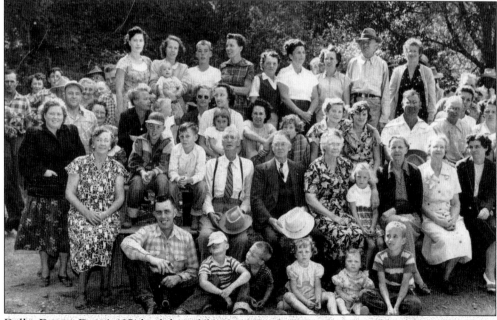

Dallas Denver Davis's 1951 birthday celebration was a festive event. He was 75 and is in the center wearing suspenders. (Cash Wolford.)

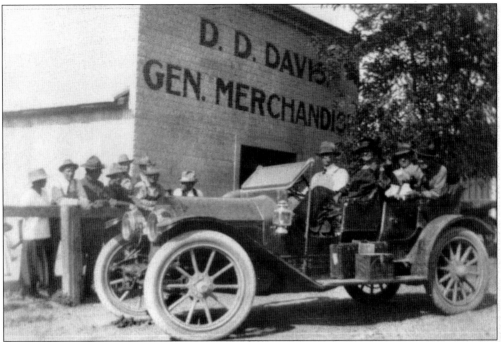

D. D. Davis became a Cadillac collector. Here the family is taking a drive in an acetylene-lamp touring car in front of Dallas' General Merchandise Store. Davis was one of the early store owners who carried everything. Eventually carrying too many local accounts on credit and facing bankruptcy, he had to close the store. He moved to Santa Maria, where he opened a café. His Los Olivos store was rebuilt and became Patsy's Bucket o' Blood saloon.

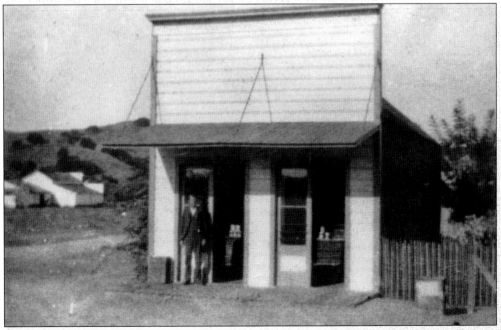

Later becoming the post office with combination locks, the original Uncle Tom's Store offered small grocery sales. "Uncle" Tom Davis is standing in the doorway.

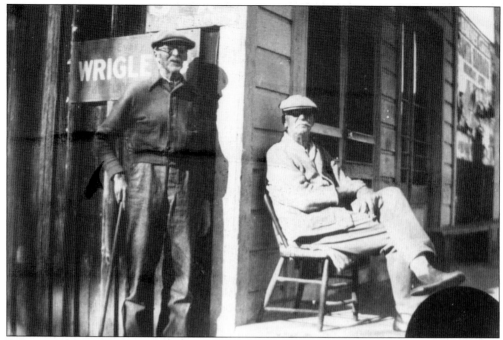

Relaxing in front of Uncle Tom's Store are brothers Will L. Davis (left) and Thomas J. Davis. Every morning, local politicos sat on a railroad-tie bench outside the store, settling important matters. Signage includes advertising for Star Tobacco, Wrigleys, and, on the building next door, the Barnes Circus, set to camp at Santa Barbara in April 1915. (Pat Kudera.)

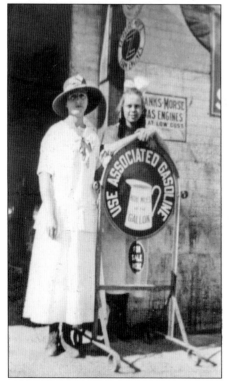

The Bernard Davis Garage was situated where Lavinia Campbell Park is today. Here Bernard Davis pumped Associated Gasoline and sold Fairbanks-Morse gas engines "at low cost."

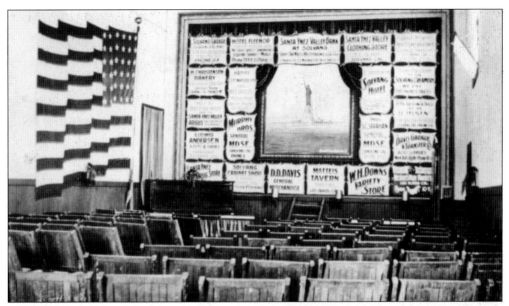

The Liberty Theatre offered seating for 100 people, and the fire curtain contained advertisements from the following local businesses: clockwise from top left, Solvang Garage, Hotel Fleenor, Santa Ynez Valley Bank (Solvang), Santa Ynez Valley Clothing Store, illegible, Solvang Hotel, Solvang Creamery, illegible, S. C. Strahan, Davis Garage and Transfer Company, illegible, Mattei's Tavern, D. D. Davis General Merchandise, Solvang Cabinet Shop, Santa Ynez Drug Store, Murphy Brothers General Merchandise, Santa Ynez, Ludwig Andersen Shoes, *Santa Ynez Argus*, Harvey Stonebarger, and H. Christensen Baker. A depiction of the Statue of Liberty, "Miss Liberty," is at the center. (Keturah Campbell.)

Liberty Theatre
LOS OLIVOS, CAL.

Saturday & Sunday
MAY 1st and 2nd

LON CHANEY
—IN—

'PHANTOM of the OPERA"

A wonderful dramatization of the burning desire in every young girl's heart today.

This Liberty Theatre advertisement is from April 30, 1926. Also showing that year were *North of 36* with Wallace Beery, *Fool's Highway* and *The Rose of Paris*, both starring Mary Philbin, *The Mad Whirl* with May McAvoy, *The Vanishing American* with Noah Beery, and *Flaming Waters* starring Malcolm McGregor.

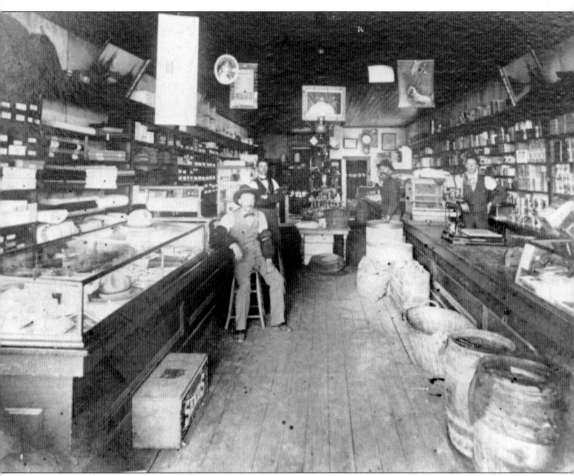

According to the 1908 clock on the wall of the D. D. Davis General Merchandise store, the time was 5:30 p.m. Seated on the left is John Loustalot with Dallas Davis standing behind him. Al Thrailkill is standing by the barrel and to the far right. Behind the counter stands Bernard Davis. Loustalot was the bartender at Tolladay's Saloon and at Mattei's Tavern. Dry goods—hats, yardage, shoes, and the like—were sold on the left and groceries and tobacco on the right. Milk chocolate, jewelry, and watches were available at the back of the store, and a bunch of bananas hung from the ceiling. Merchandise displayed includes Schilling's Best Coffee, Battle Ax Plug, Bromo Quinine—"a laxative for colds"—and Piper Heidsieck Plug, which, according to the display, "has been reduced in price and improved in quality." (Cash Wolford.)

Attired in gloves, a suit, and a tie, the Los Olivos barber, Al Thrailkill, poses for a photographer. It appears to have been an uncomfortable ride, for his bike has no brakes or padding on the wire-frame seat, and all the local roads were dirt or gravel.

The 11-member William Taylor Downs family is photographed around 1895. The family's second child died at a young age. Standing from left to right behind Will and Maggie Downs are their children: William Henry, Andrew Jackson, John Shelby, George Taylor, Rhondo Bell, Addie Ruth, Wren Jane, Robert Benton, and Grace Olive.

In the interior of William Henry Downs's Variety Store are, from left to right, W. H. Downs, a salesman, and Downs's son Nielsen. The chair at far right was used for barbering. Etelka (Davis) Downs ran the town library here for many years.

William Henry Downs's 1924 receipt to the Chester Whitcher Cattle Company is shown here. (Ruth Sahm.)

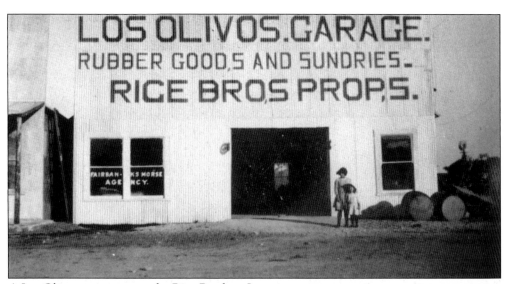

A Los Olivos mainstay was the Rice Brothers Los Olivos Garage. Built by Claud and Frank Marion Rice, this was the first valley automobile agency, selling "the Universal Car," a Ford. Cart-Red gasoline was originally pumped out of barrels into five-gallon cans. Many brands of gas have been sold here over the years, including Standard, Chevron, Richfield, Arco, and Union. During the filming of *Return to Mayberry*, the garage became the G & G Garage, managed by Gomer and Goober. It currently houses Wine Country Home, Panino, and Tensley Wines. (Gertie Rice Campbell.)

This advertisement for Davis Garage and Transfer Company in Los Olivos, capitalizing on the popularity of Fisk Tires, appeared in a 1917 edition of the *Santa Ynez Argus*.

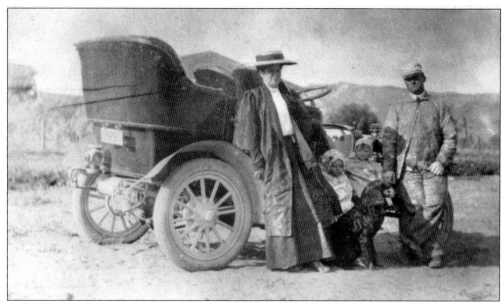

Harry Rice was an engineer/mechanic on the Pacific Coast Railway. Here the properly attired family—from left to right, Cora, Cicie, Ruth, the family dog, and Harry—show off their new car. Ironically, Cora and one child later died when the Rice automobile turned over on the "cut" while returning to Los Olivos.

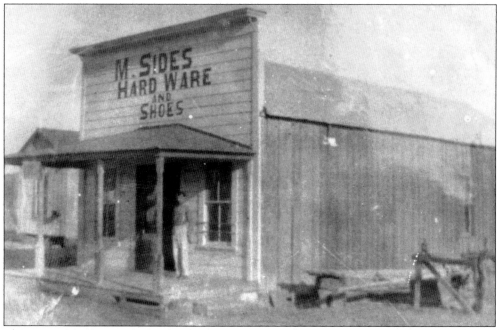

The original balloon-walled Sides Store was built as a single story by Milburn Sides in 1901. Milburn is standing next to the front door. The Sides family came to Los Olivos from Nebraska in 1893 and had a home built on Steele Street. In 1914, the store was enlarged with the addition of a second story. Used for meetings and dances, the building swayed back and forth, especially noticeable to dancing couples. A 1924–1925 account book lists 97 customers from Andrews to Yoakum.

The children of Milburn Sides and his wife, Leila Amber "Bird" (Bloodgood), are, from left to right, Carl, Hazel, Maud, and Sadie.

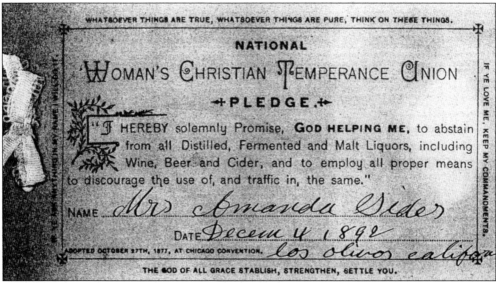

During the 19th century, the Women's Christian Temperance Union (WCTU) was a national movement, and several local women were members, including Amanda Sides and Lucy Mattei. In spite of old rumors, there is no real evidence that businesses in Los Olivos did not continuously serve booze, beer, or wine.

The Sides Store safe was saved by Fraser MacGillivray, who grew up in Los Olivos then moved to Adelaida, near Paso Robles, California.

This undated, early letter was written by Sadie Sides to her mother, Bird (Bloodgood) Sides, the wife of Milbury Sides. Maude is Sadie's sister. The teacher was probably George Chester.

Dear Mama it was cold this moring.
Idixa wasn't to school to day
we just had are gramer.
the teacher is cross to day: he said he was
I like to write Letters I wish you would
write I am glad we got our new books.
Syble Tonnel came to day. I have to write
mayd a Letter. I like to write with ink.
it is nice to day. I rote this
Letter to noon. all the children was
to school but there the teacher though
my gramer was all right.
I like to go to school. I wish I was out of
school. I gues I will closs my Letter.
write soon. from Sadie Sides

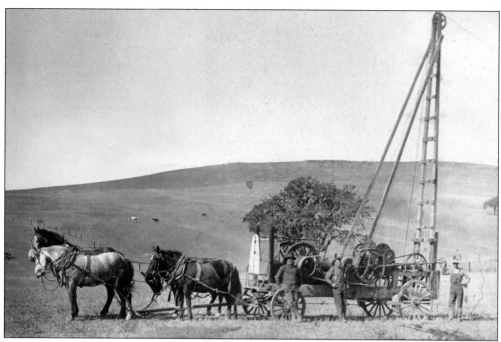

Harvey Stonebarger built a foundry on Grand Avenue, where he was able to machine almost anything. His drilling rig enabled many ranchers, residents, and businesses—including the Los Olivos School—to have potable water. Harvey's wife, Nellie, acted as postmistress for a number of years.

Here is a Stonebarger receipt to P. N. Montanaro for lumber transport. (Katherine Montanaro Fitzgerald.)

STATEMENT OF ACCOUNT No.

Los Olivos, Cal., _____ *191*_

M. 1. P. N. Montanaro

TO **HARVEY STONEBARGER**, DR.

BLACKSMITH AND MACHINIST

AGENT FOR INTERNATIONAL HARVESTER CO.

AUTOMOBILE SUPPLIES AND REPAIRING GASOLINE ENGINES
AND FARM MACHINERY

WELL DRILLING AND PUMPING PLANTS A SPECIALTY

1% PER MONTH INTEREST CHARGED AFTER 30 DAYS. ALL ACC'TS DUE AND PAYABLE THE 1ST OF EACH MONTH

MCBRIDE CARBON COPY BILL LEDGER MCBRIDE LEDGER MFG. CO. SAN FRANCISCO

55	2 x 6	16'	8 80
4	2 x 6	14	56
2	2 x 4	16	21
4	4 x 6	20	1 60
1	4 x 4	20	27
21	4 x 6	14	5 88
2	4 x 6	16	64
3	1 x 12	16	48
2	1 x 6	16	16
26	1 x 12	18	468
14	2 x 6	14	196
8	2 x 4	12	64
24	2 x 4	14	224
9	4 x 4	14	168
6	4 x 4	16	128
12	2 x 4	12	96
4	1 x 12	12	48
			0 25 2

The Harvey Stonebarger family was photographed at the Figueroa Mountain Lookout tower around 1947. Included in the photograph are Carl, Clara, Hester, Iris, Josie, Nellie, Rhonda, and Rozanne Stonebarger and Eva and Ray Atterbury.

In order to honor its veterans of World War I, the Town of Los Olivos had Stonebarger build a 64-foot flagpole. The pole was originally seated on an empty Schilling's coffee can. This was the first flagpole in Santa Barbara County to be erected in honor of World War I veterans. Uncle Tom's Store can be seen at the rear.

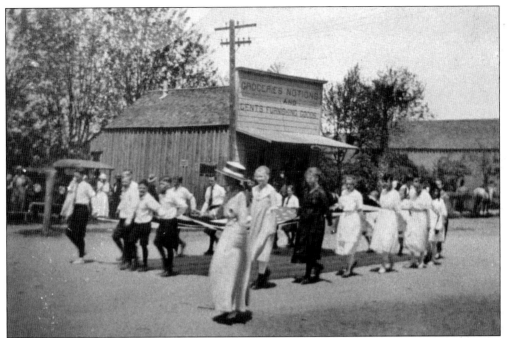

In 1918, teacher Madge Cooper led the Los Olivos School pupils down Grand Avenue to the first flag-raising. The flag was large enough to bend the pole in a brisk breeze. Madge taught in Los Olivos in 1916 and 1917.

Standing at the 1918 dedication of the flagpole were, from left to right, World War I veteran Reuben L. DeVaul (1892–1976) in an ill-fitting jacket and Civil War veteran John Hartley (1846–1923). Uncle Tom's Store can be seen on the left. (Mrs. Carl Campbell.)

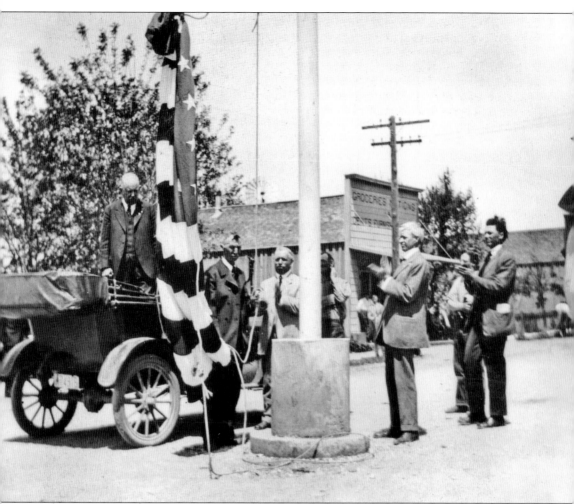

On May 3, 1918, an appropriate flag-raising celebration was attended by, from left to right, Judge T. R. Finley of Santa Maria (standing in the Model T), John Hartley, Reuben DeVaul, Peter Montanaro, Rev. Kenneth Brown of Santa Ynez, Dallas D. Davis, and the townsfolk. The ceremony was followed by a barbecue for 300, a street dance, and fireworks. A cake, made by the wife of Lupe Munoz Sr., was served. Twenty-one-year-old Charley Berry felt "real good" after drinking some homemade brew—10 gallons he had concocted with the help of friends. According to Charley 63 years later, after reciting a "good" sermon, he slowly climbed up the flagpole.

For many years, a member of the Los Olivos Improvement Association voluntarily raised and lowered the flag each day. Today it is lighted at night and flies 24 hours a day, 7 days a week. Upon the death of a Los Olivos resident, the flag is flown at half-mast until the funeral. (Beverly Whitmore.)

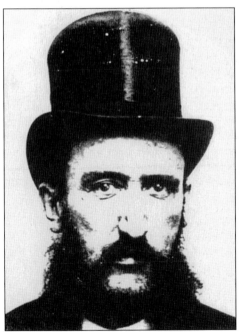

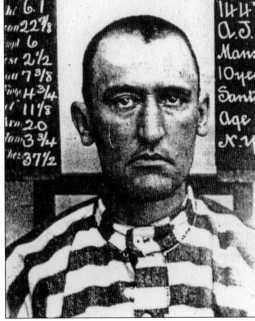

In a fit of alcoholic rage in 1892, the 45-year-old pharmacist, Dr. A. J. Lawrence, beat his wife, Florence, the Los Olivos postmistress, to death. Convicted of manslaughter, he was sentenced to 10 years at San Quentin. Inmate No. 14470, he was discharged on September 14, 1897, after serving five years. Dr. Lawrence did not return to Los Olivos. (California State Archives.)

The Keenan/Hartley/Barnes balloon-walled home was moved in 1998 to a site behind Mattei's Tavern, where it was remodeled and is now the Wildling Art Museum. This is the oldest wooden building in Los Olivos, and its integrity was preserved during the move. It is Santa Barbara County Historic Landmark No. 30.

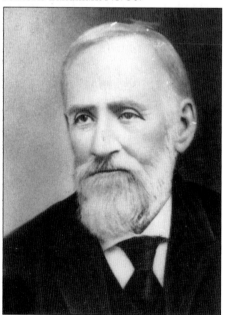 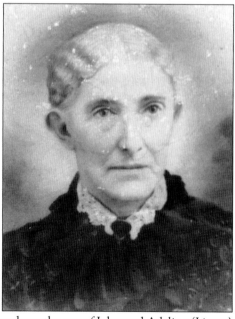

Tobias "Bi" Keenan was born around 1854 in Ohio and was the son of John and Adeline (Liston) Keenan. He was married to Amelia Fisher, Lucy (Fisher) Mattei's sister. Both sisters were from San Luis Obispo, and their father was a noted gunsmith. John Keenan's sisters were also related to local families by marriage: Linnie married a Horne, Lulu was married to Fallie "Frank" Barnes of Ballard, and Annie (Keenan) Wynan later moved to Guadalupe to take care of famed mountain-man Davy Brown.

Fred "Berkie" Fleenor and his wife, Sonora Etta "Sonie," arrived in Los Olivos from Indiana before 1905. Fred added a six-room boardinghouse to the south of an existing building and added a room in front for a restaurant with Sonie as the cook. He called the complex the Hotel Fleenor. When the Danes began arriving in 1911, many stayed here as there was no housing in Solvang. The boardinghouse section burned down in 1923, and the building has housed numerous residents and businesses over the years. Remodeled, it is currently Fess Parker's office. Poul Palmer sells his vegetables—including 60 varieties of garlic—at his Los Olivos Farm stand on the corner of Grand and Jonata Avenues.

...Hotel Fleenor...

HOMELIKE ACCOMODATIONS
REASONABLE RATES

Main Street Los Olivos. California

A Hotel Fleenor business card is depicted. The remnants of the hotel became, today, the office of actor Fess Parker, who starred as Davy Crockett in several famous Disney productions of the 1950s then as Daniel Boone on NBC in the 1960s.

John Maguire ran a blacksmith shop in Los Olivos. On numerous occasions, he had angered local residents. Retiring on December 19, 1923, Maguire was blown up by dynamite, which had been placed under his bed. He lived for a day and implicated several well-known locals, but no one was ever convicted of the gruesome crime. From 1975 to 2002, this building was the Cody Gallery with owner-managers Bob and Beverly Whitmore. It is currently the Judith Hale South Gallery.

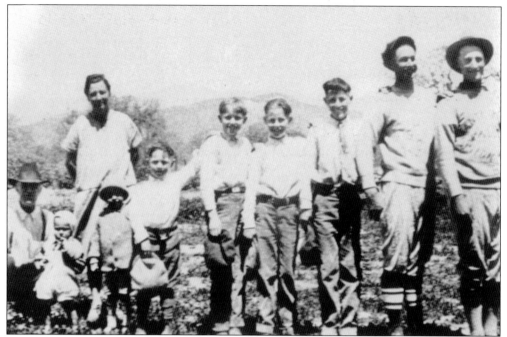

The sports-minded Fitzgeralds' claim to fame was that they could field an entire baseball team with their sons. Included in this 1926 photograph are, from left to right, Frank Fitzgerald and his wife, Ida (Hevin) Fitzgerald, with sons Bill, Ed, John, Norman, Jim, Dennis, Roland, and Kenneth. As a catcher, Ed played 12 years in the major leagues, from 1948 to 1959, for the Pittsburgh Pirates, Washington Senators, and Cleveland Indians. He ended his career as manager of the Fresno baseball team.

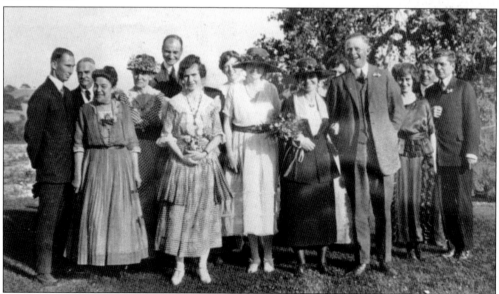

The MacGillivrays moved from their Los Alamos ranch to their Figueroa Mountain Road ranch in Los Olivos; here local residents have gathered for a party. Included on the guest list were Alden March Boyd, Lucy Mattei, Margaret (Alexander) Boyd, Marrietta "Etta" MacGillivray, Joan Bard, Jessie Boyd, Will Phelps, Barbara Phelps, and Ramona and Alonzo Lansing. (Bill Phelps III.)

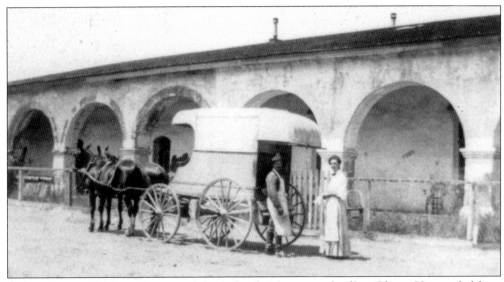

Peter Montanaro built a cow, pig, and sheep slaughterhouse south of Los Olivos. He traveled from Sisquoc to Nojoqui selling fly-covered meat to regular customers. To entice youngsters to tell their moms he was nearby, he bribed them with a slice of his salami. The children also liked to swim in the small, dammed area north of the complex. Here Peter is seen at Mission Santa Ines around 1905 showing his wares to Mamie Goulet. (Katherine Montanaro Fitzgerald.)

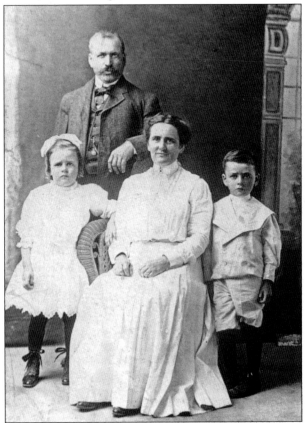

Peter B. Montanaro's family members, shown around 1910, are, from left to right, Beatrice, Pete, Marina, and Arthur "Art" Phillip. The patriarch, Peter, was born near Genoa, Italy, in 1857 and arrived in the United States in 1879. He farmed on the Zaca, Bell, and Santa Ynez ranches and, in 1903, was married to Marina Lodovina Casserini, born in Switzerland in 1878.

Jean Baptiste "John" Libeu homesteaded Zaca Lake in 1890. He and his wife, Catherine Bischacle, had five daughters: from left to right are Rosadell Inez, Anna Alberteen, Eulalia Eugenie, Louise Fronteen, and Marie Honore. John also had a son, Matthew, who was born earlier in Sisquoc. John became a forest ranger and ran a private resort at the lake. The 1917–1921 register lists 160 guests—Abels to Westwick. Zaca Lake is one of the few natural lakes in Southern California and is also unique in that it turns over several times a year, giving it a purple cast. It is not, as rumored, "bottomless" but 42 feet deep. (Jim Blakley.)

A party for Howard Sahm celebrated his fifth birthday. (Ruth Sahm.)

Los Olivos's "finest" are pictured from left to right: (first row) Dallas Davis, Gib Brown, and Don Farmer; (second row) John Carricaburu and Dib Brown. (Cash Wolford.)

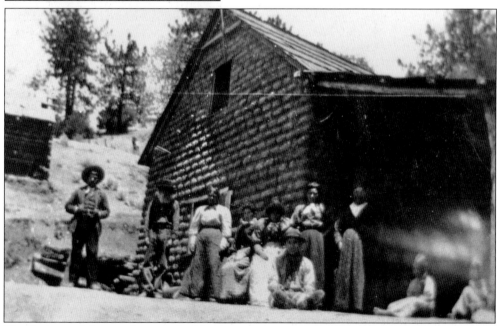

The Figueroa adobe was photographed here on what is now called Figueroa Mountain. The adobe might have been built as early as 1877; the property was homesteaded in 1889. Patricio Figueroa (1826–1911) and his wife, Maria Dolores Martinez (1849–1902), were married at Mission Santa Ines in 1865 and lived on the mountain with their children. Nothing of the adobe remains today. The Figueroa children were Adelaida, Juliania, Manuela, Pablo, Matilda, Luisa Eusebia, Modesta, Ysabel, Juana, Jose, Seberino, Ramona, Petra, and, possibly, Cielos. (Barbara Tunnell Phillips.)

Seven

NEARBY TOWNS

The other settlements near Los Olivos in Santa Barbara County's wine country have all had social and economic symbioses as members of the Santa Ynez River Valley community.

BALLARD: Following the death of his business partner, William N. Ballard, government surveyor George Lewis purchased homestead land that had formerly been a rancho belonging to the Native American Marcelino, then Cesario Lataillade. Lewis later platted Ballard. With the arrival of the railroad in Los Olivos, the early businesses in Ballard closed or relocated to Los Olivos or Santa Ynez. The early Presbyterian church, now the Loper Chapel, remains in business today.

SANTA YNEZ: Developed by an agent of the Catholic Church, this town's 160-acre lots were offered with a $15 town lot bonus. Homes were centered on today's Sagunto Street, and by the end of the first year's sales, 29 buildings had been constructed. The crenellated, redwood Santa Ynez Hotel, a regular stagecoach stop, offered rooms to stage passengers. Dances were held at Greer's Hall and then at the Red Barn. Minetti's delicatessen offered lunch and dinner. Several saloons served beer, available with 5¢ tokens, and whiskey. The Chumash Casino now offers gambling, several restaurants, a hotel, and Las Vegas–style entertainment.

BUELLTON: The Buell family developed what we now know as Avenue of the Flags, Pea Soup Andersen's restaurant and hotel, and the community of Buellton. R. T. Buell fenced his entire ranch and, like Felix Mattei, had a self-sufficient operation. He ran into financial difficulties and eventually lost the eastern half of his rancho, which was taken back by a San Francisco bank. In 1910, this land was sold to Danish settlers and later became Solvang.

SOLVANG: Settlers from Denmark living in the Midwest sought West Coast land on which to build a traditional college, settling on the eastern portion of the old Buell Ranch. Staying in the Fleenor Hotel in Los Olivos and at the building east of Mattei's that had once housed Short's Acme Saloon, the Danes went to work. Residents assumed they would be hired by the Danes but were surprised to discover they could do all the construction themselves. Word of the Danish community spread, and until 1935, shopkeepers were required to speak Danish. Copenhagen Street was originally Mexican-styled, but following World War II, the Danish *bindingsværk* architecture was adopted. Solvang, supported by the Alisal Guest Ranch and two golf courses, continues to enjoy a vigorous tourist trade.

William N. Ballard was founder of the Santa Ynez Valley section of the 1861 Coast Stage Lines. Ballard was married to Cynthia Lunsford shortly before his death, and his widow then married George Lewis, who developed the town of Ballard.

The Lyons family arrived in Ballard in 1882. Grace Lyons and her sister, Jeannette, were teachers in local schools. Both sisters were instrumental in the formation of the Santa Ynez Valley Historical Society, and Grace, shown here, was also a stringer for the *Santa Barbara News-Press*.

Formerly a store and gas station, John and Alice Elliot's Ballard Store was a Santa Ynez Valley favorite for over 20 years. A carefully selected wine cellar; eclectic, international entrées; and Alice—reciting John's prodigious dessert list—kept customers returning repeatedly, with reservations (often two months in advance) a must. Though the Ballard Store Restaurant has been closed for a number of years, it continues to be sorely missed.

Originally painted railroad yellow, Ballard's Little Red Schoolhouse has been in continuous use since 1881, when the children met in a granary owned by George Lewis, then a saloon. The current building was ready for occupancy on December 20, 1883, with the belfry added later. Reminding visitors of the one-room-school era, the schoolhouse is a major tourist attraction. It is listed as Santa Barbara County Historical Landmark No. 5.

This was, presumably, Ballard's original "post office."

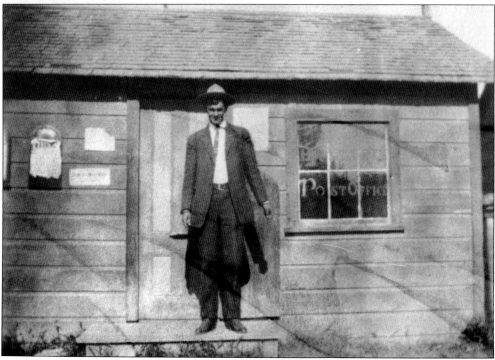

Sam Lyons is pictured at a post office owned by Robert Smith in the early 1900s. A former lighthouse keeper, Smith was the Ballard postmaster for 26 years. (Norman Davison.)

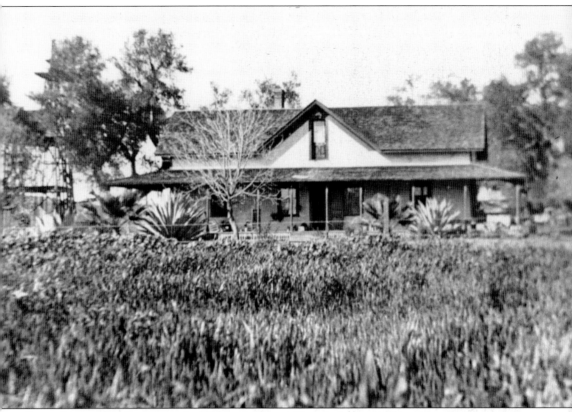

Formerly named La Fonda, Fondo del Pintado, Alamo Pintado Inn, and Alamo Pintado Adobe, this remodeled adobe currently houses the Rideau Winery. It was constructed by English remittance men D. B. W. Alexander and a Mr. Grundy. At one time, A. M. Boyd, with Felix Mattei as manager in 1894, offered wealthy, chauffeured world travelers a fashionable getaway, which included meals and lodging. The site is Santa Barbara County Historical Landmark No. 12.

BALLARD!

Booming!　　　Booming

Choice Lots for Sale in the Town of BALLARD from $75 to $300.

THE OJAI OF SANTA BARBARA COUNTY.

Only one day's drive from Santa Barbara. Soil, climate and scenery unsurpassed. T thriving little town is situated in the beautiful and fertile valley of the Santa Ynez, on the of the narrow gauge railroad now building down the coast from Los Alamos. Ballard is coming town and health resort of upper Santa Barbara County. Stages from Santa Barb every day. For further particulars inquire of J. A. KENNEY, at the Bon Ton Millin House, Oreña Block, State steeet. Map and plat of Ballard can be seen at the Bon Ton.

This advertisement touted the town of Ballard in the *San Francisco Journal of Commerce* in October 1887.

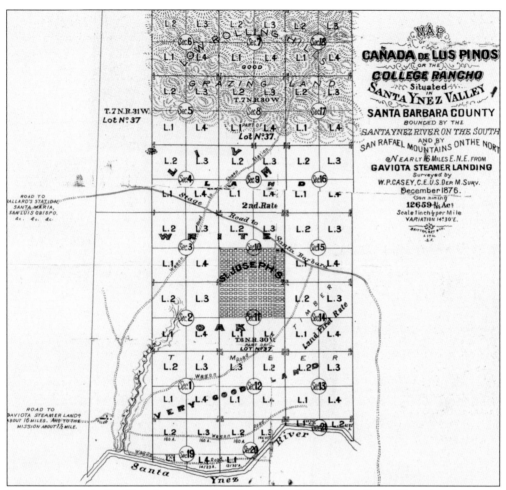

In 1876, the Catholic Church attempted to develop a subdivision in Santa Ynez that they were going to call St. Joseph's. Although it is registered in Santa Barbara County records, the proposed development never took place.

Sagunto Street in Santa Ynez is seen looking westward toward the second high school around 1915. Included in the view are Maggie Lewis's Hat Shop, Pertica's Saloon, and Greer's and Minetti's Deli.

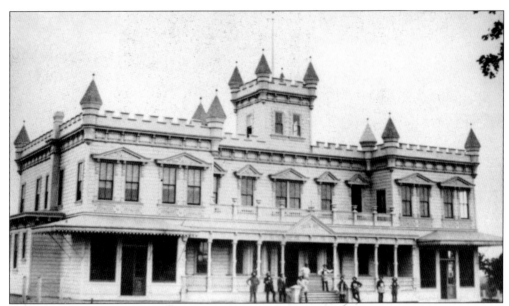

The imposing College Hotel in Santa Ynez was sometimes used as a movie set. The turrets were eventually removed, as woodpeckers had pecked them full of holes.

Fourteen Knight family members are seen here: from left to right are (first row) Eugene, Clyde, mother Julia Ann (Fillmore), Dick, and Philip; (second row) Patty, Sylvia, Phyllis, Ellie, Roberta, Violet, Fern, Ethel, and Flossie. (Flossie Beals.)

Tomas Ontiveros (left) with Santa Ynez constable Alonzo "Lonnie" Crabb, far right, enjoy a cool one with an unidentified friend in 1936. Crabb was valley constable off and on from 1885 to 1942 and was married to Isabel Maris in 1883. Crabb was superintendent of the Pierce brothers' Alisal Ranch from 1886 to 1893, and Ontiveros worked for him. In 1908, Lonnie, still cowboying, returned from Mexico with 700 longhorn cattle for a Santa Ynez ranch.

A Santa Ynez baseball team is pictured in 1910. From left to right are (seated) Hugh Burum, Carlow Fulwider, Harry Lee, Charlie Gott, and Fallie Barnes; (standing) Brick Buell, Johnnie Kane, Warren Parker, Roman de la Cuesta, and Carl Gott. Local baseball teams competed with teams from Ballard, Santa Ynez, Santa Maria, and, eventually, Solvang.

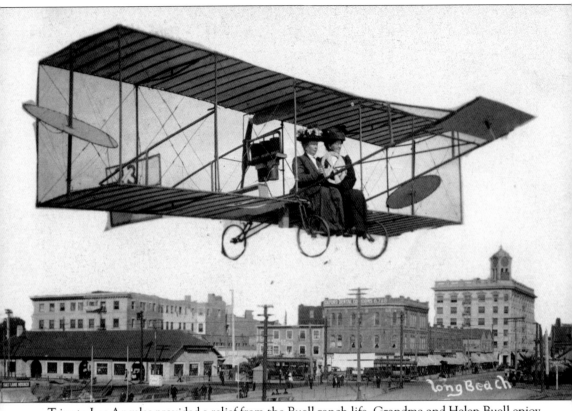

Trips to Los Angeles provided a relief from the Buell ranch life. Grandma and Helen Buell enjoy a Long Beach carnival attraction. The pusher plane is "flying" on wires. (Lucy Buell.)

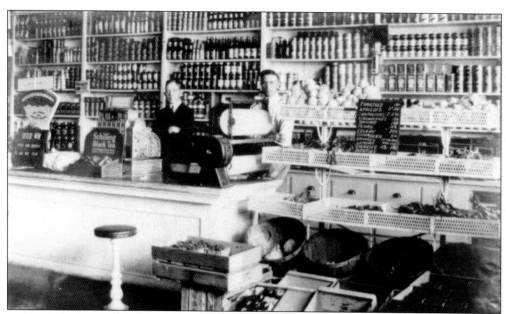

This was the Solvang Co-operative Store decades before the town became one of Santa Barbara County's top tourism destinations. (Leon Roeser.)

One of Solvang's working windmills, this structure was engineered by blacksmith Kris Klibo—"Night Mayor of Buellton." Many of Klibo's iron art pieces can be enjoyed throughout the Santa Ynez Valley.

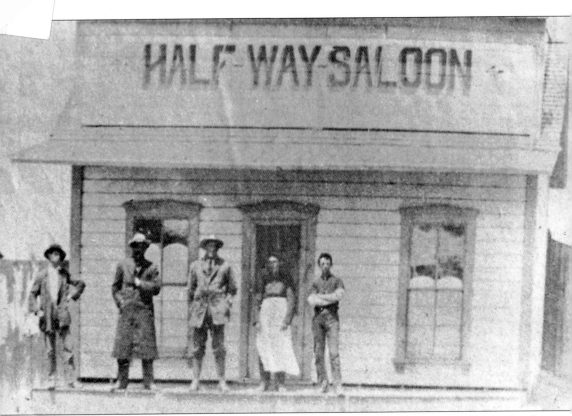

The original road north from Los Olivos to San Francisco followed today's Foxen Canyon Road through Sisquoc, Garey, and Suey to Nipomo. The Half Way Saloon, owned by Pete Nogues, seen here around 1905, was situated on Wick Avenue and Foxen Canyon Road in Garey, 20 miles north of Los Olivos. Pictured from left to right are Allen C. Goodchild, F. Napoleon "Pancho" Ontiveros, Ramon N. Goodchild (proprietor), Valentine B. Calderon, and Tom Lakey.

Eight

LOS OLIVOS SCHOOLS

When enough children were living in a rural area, the state gave $50 to support the opening of a school. On October 4, 1888, a one-room subscription school situated near Mattei's Tavern housed 15 in Los Olivos's first school. Classes were held here for a year; they were later held in a cottage in town owned by Alden March Boyd. With P. A. Summers giving the dedication, a cornerstone was laid for the first Los Olivos school building on June 1, 1889. Several months later, on September 28, 1889, the townspeople voted 10-0 to use $550 to construct a school.

Water was carried from Tom or Bernard Davis's homes, and two facilities (outhouses) were placed on the playground. Lanterns supplied the lighting, and the average attendance was 45. Activities included tennis, handball, and baseball. Early teachers were Anne Hosmer (1889), John S. Curriyer (1894), J. B. Hankensen and Emma Floyd (1896), Mary E. McCabe (1899), a Mrs. Hudson (1902), a Mrs. Elliott (1903), and George Chester (1904–1909).

After this first building was damaged by the 1925 Santa Barbara earthquake, it was demolished and school was held in a small building downtown. In August of the following year, townspeople voted 76-4 for a $12,000 building fund. At this time, William Stayton was the principal and Patricia Neely the teacher. Hans Skytt of Solvang completed the second school in 1927. In addition to two classrooms, it held a gym, an auditorium with a small stage, an office, and a basement. A boy's shower room was added later. The school had electric lights, a heater, and an electric stove. Water was piped in, and there was hot water in the basement kitchen where lunch was prepared. (Before the construction of this school, there had not been an indoor basketball court in the Santa Ynez Valley. This gym had such a low ceiling that the basketball players became adept at shooting through the rafters.)

With an increase in enrollment, a third teacher was required. The local mothers' club decorated a portion of the basement where an intermediate class was held until 1953, when two portables were added.

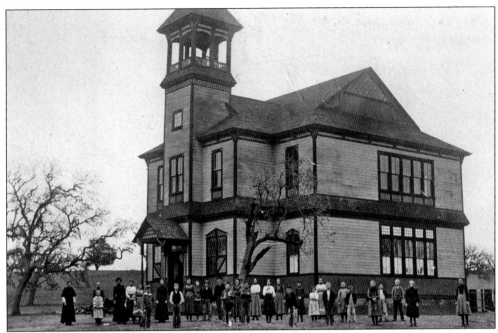

The entire student body, 30 children, is pictured with the teachers at the wooden, two-story Los Olivos School in 1890. The boys' and girls' "necessaries" are located at the right. Water from Uncle Tom's well was brought to the school each morning in a bucket. The second floor of the building, never completed, was used for band practice and storage. One year, the day after Halloween, students were delighted to arrive at school and discover pranksters had hoisted a cow onto the steeple. The school yard was later fenced with a gate in back. After the 1925 earthquake, the school was declared unsafe, and with considerable difficulty, it was torn down. The cornerstone has disappeared.

This souvenir card lists 39 pupils attending Los Olivos School in 1899. In the late 1890s, state-enabling legislation allowed grammar school districts to cooperate in forming high school districts. On August 22, 1896, representatives from nine local elementary school districts met at College School in Santa Ynez to organize, locate, and name a Santa Ynez Valley high school. The representatives, voting 18 over 9 for Los Olivos, agreed that the second floor of the College School building would be used as the high school. (Barbara Tunnell Phillips.)

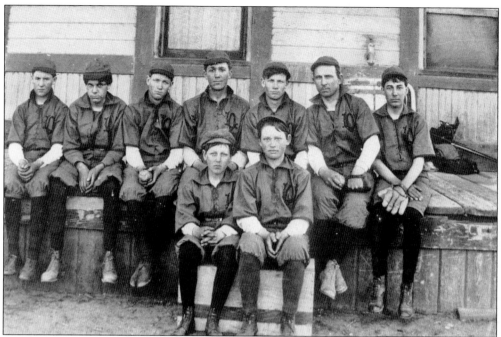

The Los Olivos School baseball team appears in uniform, looking glum, around 1905. In the back row are teacher George Chester and student Bert Mattei, on the right. Notice the size of Mattei's glove.

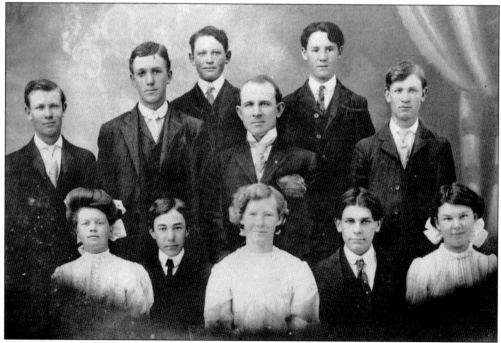

The 1907 Los Olivos School graduation class is depicted. From left to right are (first row) Mae Barnes, Bert Mattei, Evelyn Fox, Ben Best, and Clara Whitcher; (second row) Dilbert "Dib" Brown, Don Farmer, Lloyd Henning, teacher George Chester, Ernest Smith, and Gilbert "Gib" Brown.

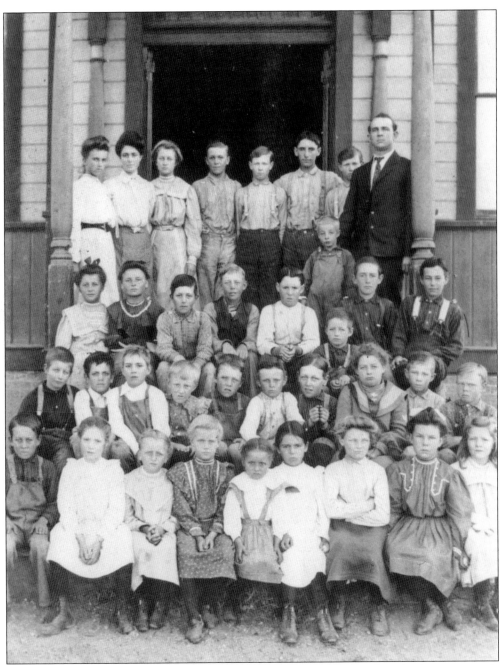

In 1906, thirty-five Los Olivos students, grades one through eight, posed on the front steps with their teacher, George Chester. From left to right are (first row) George Hartley, Nettie Parr, Sadie Sides, Ethel Barnes, Mamie Phillips, ? Tolladay, Sadie Tunnell, Clara Whitcher, and Edna Farmer; (second row) James Fields, Sam Parr, Alan Rector, Carl Sides, Walter Hartley, Russell Tunnell, George Campbell, Eddie Fields, Maude Fields, Rueben Brown, and Rencil Cooper; (third row) Della Davis, Gertie Tunnell, Earl Farmer, Charles Barnes, Ernest Smith, Jessie Rector, and Bert Mattei; (fourth row) Lilly Petersen, Sophia Parr, Nora Davis, Don Farmer, Dilbert Brown, Harry Rector, Gilbert Brown, teacher George Chester, and Leo Fields.

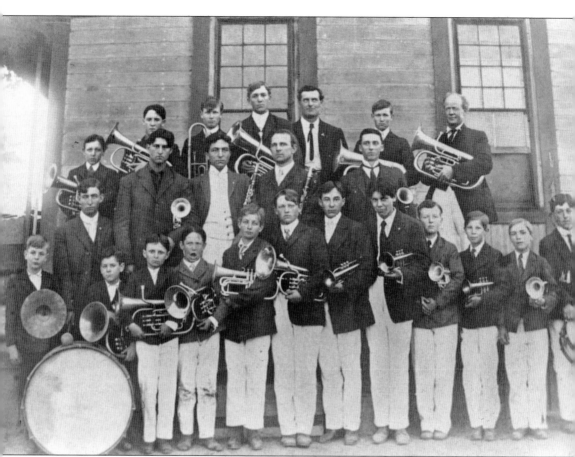

The Los Olivos brass band stands on the school steps. From left to right are (first row) Leo Fields, Harold Ward, Russ Tunnell, Art Henning, Jim Fields, Lloyd Henning, Clarence Mattei, Ben Bess, Laurence Fox, Rueben Brown, Roland Rector, and Earl Farmer; (second row) Bill Fields, George Campbell, Bert Frier, director George Chester, Charlie Mattei, Dallas Davis, and unidentified; (third row) Ernest Smith, Gib Brown, Don Farmer, unidentified, Dib Brown, and Louis Fox.

The Los Olivos student body in 1938 is pictured here. Grades one through four were taught by Louise Ingle, with an enrollment of 12 boys and 8 girls. Ingle was credited with 3,018 days of attendance. Marion M. Oldham taught grades five through eight with an enrollment of 6 boys and 7 girls. She was credited with 2,570 days of attendance, which determined state reimbursement.

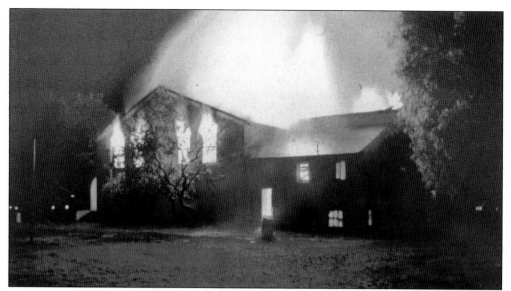

The abandoned, second Los Olivos School building was to be used as a senior center, but on November 1, 1978, local children who were playing in the basement started a fire and the building was a total loss. The early school records, stored in the basement, were also lost.

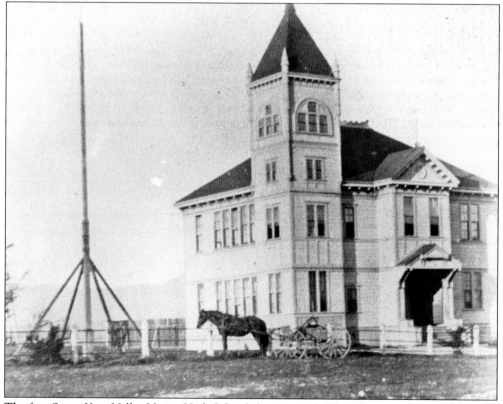

The first Santa Ynez Valley Union High School classes were held on the second story of this, the College (elementary) School building. Students walked, rode on horseback, or drove buggies to school each day; some lived with family friends in Santa Ynez. The flagpole can be seen at left.

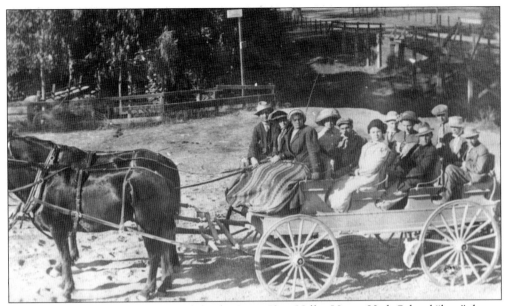

Jim Fields was the driver (1912–1914) for the Santa Ynez Valley Union High School "bus," shown at Lansing's Corner in Los Olivos. Notice how well-dressed the students are for a day at school. From left to right are (first seat) driver Jim Fields, Sadie Tunnell, and Maude Fields; (second seat) Della Davis, Ben Best, and Clara Whitcher; (third seat) Russell Tunnell, Barbara MacGillivray, and George Campbell; (fourth seat) Bert Mattei, Rueben Brown, and Jack MacGillivray. Scheduled bus pickup was available shortly after this photograph was taken. Looking west across Lansing's Bridge, the windmill to the back is on the Ballard adobe property.

The 1921 high school basketball team is, from left to right, (seated, first row) Ludwig "Lutch" W. Burchardi and Nels Nelson; (second row) John L. Donahue, Jim Anderson, and Henry L. Minetti. Not pictured is Emmett Edwards. The team was comprised of five players plus one substitute; the substitute was not an accomplished player, but when the squad was in trouble, he had to go in. Everyone played "all out" the entire game. The team practiced on an outdoor court, and their coach was James A. Westcott. Westcott, the school principal, coached all the sports.

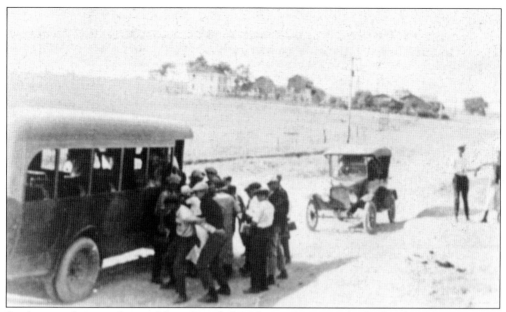

Students make a mad scramble to board the "Green Dragon," the high school bus. Decades before the idea of a bus, the school board had to decide others matters. Felix Mattei was elected chairman of the first board of trustees. Other early trustees were P. Acquistapace, James Barnes, J. F. Barnes, W. H. Cleme, D. D. Davis, Edgar B. Davison, Eduardo de la Cuesta, Ed Donahue, Thomas Donahue, Ed Doucher, Taylor Downs, E. G. Files, Isra Fields, L. L. Fox, E. Hagerman, M. P. Hourihan, Earl Jensen, Sam Lyons, Howard McNealy, J. H. Moss, William Murphy, Fred Nicolas, George Shanklin, F. W. Shaw, and J. M. Summers. (Laura Lewis Alegria.)

The 1925 senior class at Santa Ynez Valley Union High School contained 11 women and 4 men. The class advisor is unidentified. The first combination elementary/high school classes were held in the second story of the elementary College School. An imposing building, it burned down in 1908. A new high school, completed in 1910, was condemned in 1934, and classes met in tents until the present, third facility was ready for occupancy in the 1935–1936 school year. In June 2007, there were 251 Santa Ynez Valley Union High School graduates.

Over the years, numerous private schools have been available in the Santa Ynez Valley. In November 1888, at Prof. J. A. E. Summers's Institute, 15 students completed the curriculum. Derville Academy became the now much-enlarged Dunn School, and Paul and Louise Squibb, above, opened the still-continuing Midland School in 1932. Students at Midland are, philosophically, expected to participate in the maintenance and daily activities here. The Squibbs retired to Cambria, moving into a Victorian home that is now a bed-and-breakfast. Louise was so determined to keep the streets trash-free that the picking up of trash in today's Cambria is referred to as "squibbing."

Nine

LOS OLIVOS TODAY AND TOMORROW

The growing reputation of Santa Barbara wines is responsible for Los Olivos becoming a 21st-century tourist destination. Commercial property values have soared, and wine touring and tasting has become the main attraction. Wine has been an important commodity in Santa Barbara County since the early mission days. Beginning in the 1870s, the Los Angeles area produced and sold wine nationally, and numerous areas around the city of Santa Barbara were developed to meet the demand. In the 1930s, Joe Alfonso, on Baseline near Ballard, produced a tolerable zinfandel that he sold throughout the county, but when the federal government discovered he was making hooch, his winery was closed. (Surprisingly, the large copper still run by Franzina on Figueroa Mountain was not closed.)

Pierre Lafond bonded the Santa Barbara Winery in 1962 (BW No. 4490) and planted a vineyard in Buellton. Boyd Bettencourt's Santa Ynez Valley winery on Refugio was bonded in 1967 (BW No. 4753). Firestone Vineyard was bonded in 1974 (BW No. 4720). Leonard Firestone's son, Brooks Firestone, built this winery, and his son, Adam, continues the business today with a new facility in Paso Robles. At last count, over 100 wineries were located in Santa Barbara County. Los Olivos wineries and tasting rooms currently situated in Los Olivos are Alexander and Wayne, Andrew Murray, Bernat, Brander, Arthur Earl, Carhartt, Carina Cellars, Consilience, Curtis, Epiphany, Fess Parker, Firestone, Foley, Daniel Gehrs, Koehler, Longoria, Los Olivos Tasting Room, Oak Savannah, Prodigal, Roblar, Scott Cellars, Tensley, Tre Anelli, Wild Heart, Wine Country, and Zaca Mesa.

In 1990, before wine tasting entered the scene, art was a major attraction. Ten art galleries featuring prominent artists were located in downtown Los Olivos. Serving wine and hors d'oeuvres, these galleries held frequent openings for their artists.

Time and time again, Michael Jackson's Neverland Ranch has been in the international spotlight, and though his ranch cannot be seen from the road, tourists—many from out of the country—are drawn by curiosity to the site.

Political and housing pressures are responsible for proposed zoning changes that could drastically change Los Olivos and the Santa Ynez Valley. In order to save the historic fabric of the town— exterior remodels, signage, and new construction—the Santa Barbara Board of Supervisors passed an ordinance in 1972 establishing a Los Olivos architectural overlay. The town then formed two committees, the Los Olivos Improvement Association (LOIA) and the Los Olivos Architectural Board (LOARB). By county decree in 2006, the LOARB ceased to exist.

The Day in the Country celebration, always held in October, includes many events; pictured above is the Kids Run along Grand Avenue. It appears as if the adult pacer is about to be run over!

Ralph Story, a former Los Angeles radio and television personality, opened the Story Gallery with his wife, Diana, when he moved to Los Olivos. Until he became critically ill, he was a participant in community activities— whether he was acting as master-of-ceremonies promoting the town, hosting a gallery activity, or manning a barbecue.

Deep in whipped-cream beards, participants in the 1982 pie-eating contest are seen here. This winner was awarded a dinner for two at Mattei's Tavern. (Beverly Whitmore.)

Bent Clausen, driving a Mastagni carriage, escorts grand marshal Fr. Chuck Stacy in the Los Olivos Day in the Country 2004 parade. Clausen, a custom butcher from Denmark, ran Clausen's Los Olivos Deli with his wife, Anne-Lisa (also Danish), for many years. The Cafe and Wine Merchant now occupies the former deli site.

This Farmall Cub tractor is driven by Jim Carricaburu, a member of a prominent local Basque family. Carricaburu was accompanied by a large contingent of tractors in this, the 2001 Day in the Country Parade. Though the valley remains a farming community, onlookers are always amazed at the number of antique tractors that participate in the annual parade.

Born in Los Olivos, 88-year-old Walter Hartley was grand marshal in the 1985 Day in the Country Parade. Walter died later that year, and his former home has been relocated, remodeled, and now houses the Wildling Art Museum.

As a repeat winner of the Tour de France, Lance Armstrong popularized bicycling, and roads throughout the valley are traversed yearly by professional and amateur riders. In this photograph, a group of international riders pedal up Foxen Canyon Road, north of Los Olivos. The Santa Ynez Valley was selected to host the Amgen time trials in 2007 and 2008.

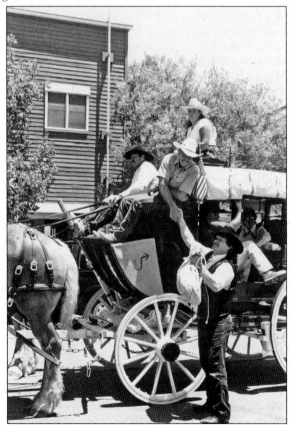

Former Los Olivos postmaster Mike Stewart accepts the Buellton–Solvang–Santa Ynez mail bag from driver Bob Mastagni's assistant in 1999. This run, by horseback and stage, commemorated Los Olivos's original mail cancel. Along the route, each postmaster stamped and placed envelopes in a U.S. Mail bag before climbing aboard the mail stage. Jake Copass and Joe Olla carried the Solvang–to–Santa Ynez mail bags on horseback along an original, dusty river trail.

Los Olivos resident Bob Herdman barbecues for Pres. Ronald Reagan and his staff at the White House in Washington, D.C. Herdman honed his skills cooking for the Rancheros Visitadores and for Ronald Reagan before he was president. Bob has never charged for his expertise. He uses 28-day aged-on-the-bone boneless strip loin, which he accompanies with pinquito beans. He serves each cut to the individual diner's plate. At the White House, he was accompanied by his late wife, Dodie, his local crew of five or six, and his barbecue trailer, which had been flown to Washington with the necessary local, split red oak. His steaks are done to his touch, never cut, and seasoned only with salt and pepper. (Bob Herdman.)

The 1986 cast of *Return to Mayberry* posed in front of the false-fronted courthouse, kitty-corner to the town flagpole. Shops in downtown Los Olivos were renamed and repainted for a one-time revisit to the heyday of *The Andy Griffith Show*, the CBS sitcom that was known in reruns as *Mayberry RFD*. Included in the photograph are cast members, from left to right, (first row) Betty Lynn (Thelma Lou), Don Knotts (Barney), Andy Griffith (Andy), and Ron Howard (Opie); (second row) Jim Nabors (Gomer), George Lindsey (Goober), Karen Knotts (Rudene), Jack Dodson (Howard), Paul Watson (Ben Woods), and Hal Smith (Otis). The film company installed a cement sidewalk around today's Lavinia Campbell Park as per their location agreement. Many locals were used as extras, providing a dedicated following when the Viacom movie was released. Other locations included a local farmhouse, the Los Olivos School, the Grand Hotel (now the Fess Parker Hotel), and a small lake in Arroyo Grande.

Bob and Beverly Whitmore were instrumental in forming the Los Olivos Improvement Association (LOIA) and the Los Olivos Gallery Organization (LOGO). They not only brought art and artists to the valley in 1972 but were also the prime organizers for the three events visitors and residents anticipate yearly: Day in the Country, the Quick Draw, and Olde Fashioned Christmas.

In 1978, Si Jenkins, owner of Jedlicka's in Santa Barbara, opened a store in Los Olivos where he continues to offer clothing and tack for ranchers.

Housed in a 1900-vintage residence formerly belonging to the DeVauls, J. Woeste displays an eclectic selection of items for the home and garden.

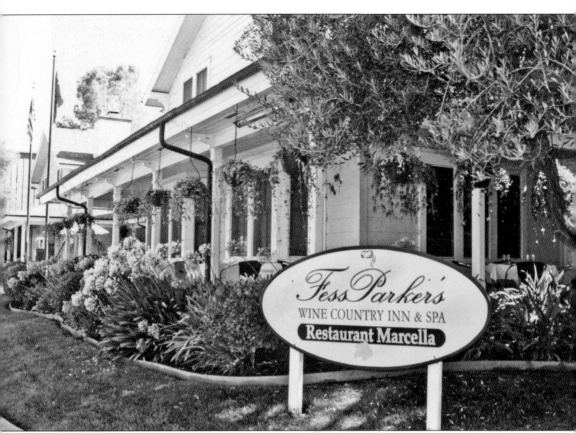

The attractive, full-service Fess Parker's Wine Country Inn and Spa also includes Restaurant Marcella.

At his Los Olivos Tasting Room and Wine Shop in the 1890-vintage building that formerly housed Uncle Tom's Gent's Furnishings, Chris Benzinger pours a number of local wines.

Local winemaker Richard Longoria offers tastings of his noted wines in the 1924-vintage, pressed-tin-fronted former D. D. Davis Warehouse Building. In Los Olivos, the wines and the buildings have vintages.

The tasting room for Daniel Gehrs Wines is located in the 1918 cottage where Mae Brown lived until her death.

Judy Hale represents numerous artists in her Judy Hale Gallery, which was, in 1889, the Downs's Variety Store.

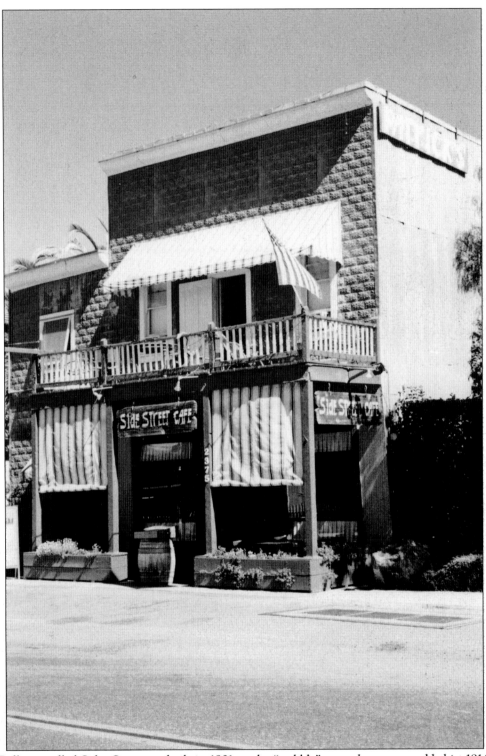

Balloon-walled Sides Store was built in 1901, and a "wobbly" second story was added in 1914. Chef Patrick Rand now serves lunches and dinners here.

Crawford Ashabraner built this now-remodeled Victorian for his wife, Cora Meadows, in 1905. Today's Tin Roof offers women's apparel and accessories.

Incorporating the English arts and crafts style of the late 19th century, St. Mark's-in-the-Valley Episcopal Church held its first service on Christmas Day 1991, with Rector Chuck Stacy presiding.

ACROSS AMERICA, PEOPLE ARE DISCOVERING SOMETHING WONDERFUL. *THEIR HERITAGE.*

Arcadia Publishing is the leading local history publisher in the United States. With more than 4,000 titles in print and hundreds of new titles released every year, Arcadia has extensive specialized experience chronicling the history of communities and celebrating America's hidden stories, bringing to life the people, places, and events from the past. To discover the history of other communities across the nation, please visit:

www.arcadiapublishing.com

Customized search tools allow you to find regional history books about the town where you grew up, the cities where your friends and family live, the town where your parents met, or even that retirement spot you've been dreaming about.

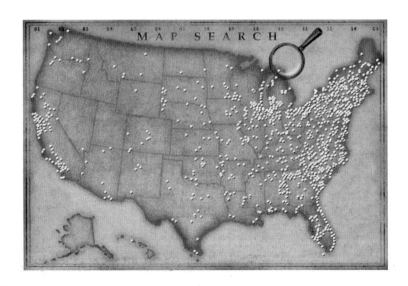